WORCESTER
THROUGH TIME
Ray Jones

AMBERLEY PUBLISHING

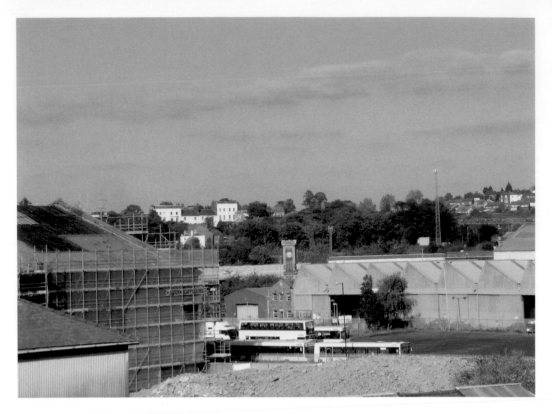

Worcester Through Time

A montage of Worcester through time as viewed from the roof of the St Martin's Gate car park in September 2009. In the foreground the vinegar works site that reflects 170 years of industrial history is undergoing irrevocable change; behind is the bus garage sited on the old Vulcan Works; then followed by the clock tower of the Victorian engineering works; a glimpse of the railway; the Georgian terrace on Rainbow Hill and finally a cluster of Victorian and later housing festooned around Holly Mount.

First published 2009

Amberley Publishing Plc
Cirencester Road, Chalford,
Stroud, Gloucestershire, GL6 8PE

www.amberley-books.com

Copyright © Ray Jones, 2009

The right of Ray Jones to be identified as the
Author of this work has been asserted in accordance
with the Copyrights, Designs and Patents Act 1988.

ISBN 978 1 84868 636 6

British Library Cataloguing in Publication Data.
A catalogue record for this book is available from
the British Library.

Typeset in 9.5pt on 12pt Celeste.
Typesetting by Amberley Publishing.
Printed in the UK.

Introduction

Like all towns and cities Worcester is undergoing constant change. In my previous look at changing Worcester in 2001 I commented that 'endless debate ensues on whether or not such change is always desirable or necessary, but, despite never ending public enquiries and planning hurdles to be jumped, the landscape of our city seems to be changing beyond recognition.' Well, in eight years nothing much has changed and Worcester continues to change, almost beyond recognition in some parts of the city.

This change, however, has been reasonably positive in the main. Nearly all of us will welcome the redevelopment schemes taking place on large sites previously used by local historic industries: Diglis Water, The Waterside, and the Lowesmoor redevelopment scheme. All of these schemes have involved the preservation and refurbishment of important and historic buildings thus considerably enhancing the quality of the new Worcester urban environment.

Also to be welcomed is the City Campus development, taking place on the old Royal Infirmary site; and the new Library and History Centre, taking place in The Butts.

Worcester is therefore taking the ambitious steps necessary in order to become a vibrant and dynamic city in the twenty-first century. However its future as a major tourist destination is still, in my view, somewhat in the balance. The loss of porcelain making at the Royal Worcester factory, ending over 250 years of continuous production, was not only a severe blow to the local economy but has, of course, also seen the end of the factory tours that brought many visitors to Worcester. Our world-class Worcester Porcelain Museum has thus been left in a rather isolated position but hopefully, when the Waterside and Diglis Water projects are complete, ways can be found to attract even more visitors to this historic part of Worcester. Worcester also continues to be blighted by traffic problems that deter day visitors in particular. Opportunities that have arisen to provide local rail links have been ignored because of envisaged cost but grandiose park and ride schemes continue to be favoured despite the fact that they

clearly do not work, are not cost effective, and blight areas on the rural urban fringe. New developments also lack the necessary car-parking provision that they clearly need.

There have been, however, several positive developments that have enhanced Worcester as a tourist centre. Chris Jaeger has admirably raised the profile of Worcester as an arts centre with his sterling efforts at the Swan Theatre and Countess of Huntingdon Hall. He also organises the annual Worcester Festival held in August that goes from strength to strength. There is also the popular Christmas Fayre and a variety of guided walks and living history. The Commandery has also been revamped and an admirable band of volunteers make Tudor House in Friar Street an attraction for both tourists and local history buffs.

Worcester is now a city of around 100,000 inhabitants and further expansion is deemed necessary by national government. Obviously expansion could be achieved but this would be at a great cost. The remaining historic core of Worcester, once one of the principal cities in England, is in danger of being overwhelmed by the sheer volume of urban expansion. Worcester, constrained by its flood plain and history, has reached its optimum size.

This book will look at some aspects of recent change but will also take a look at some previously unknown images of Worcester and compare them with the modern-day setting. While identical comparisons of views are interesting I have also tried to illustrate change through more subtle photographic observation. Modern photography can be quite a task as trees grow beyond what I deem to be reasonable. Unfettered tree growth will often obscure interesting features of the urban landscape. Traffic and parked cars do not always contribute to great photography but their presence is inevitable and this results in a stark comparison with the Edwardian streetscape where cars were almost unknown.

In conclusion Worcester is radically different from the city it was only a century ago. I personally think it could be a better place to live in and visit if government (both local and national) had shown greater foresight. But Worcester has probably fared no better or worse than countless other urban conglomerations of a similar size. The problem is really that Worcester should have fared far better than many other towns and cities because of its past historical significance.

Ray Jones
(www.surfworcester.co.uk)

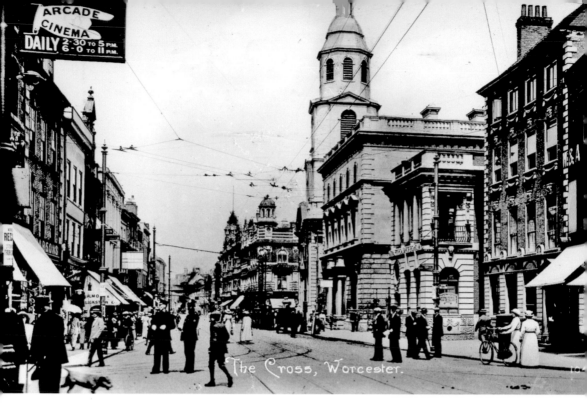

The Cross

The old postcard was franked in December 1917 and shows a bustling city-centre scene. There is, however, a relative lack of motor transport. Note the large sign pointing towards the Arcade Cinema that was situated on the south side of St Swithin's Street and appeared to have opened between 1912 and 1916. The rear entrance to Superdrug is now located where the cinema frontage would have been. A taxi rank now dominates The Cross.

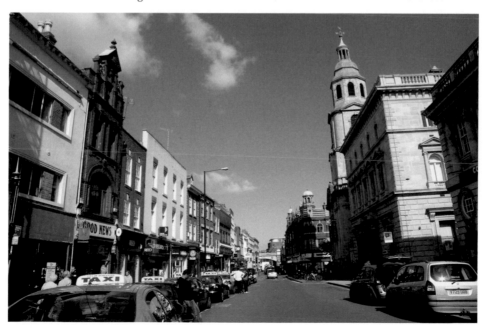

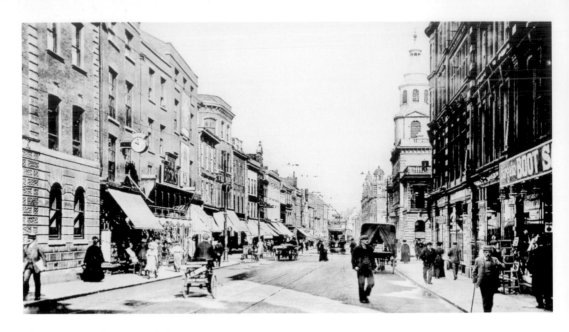

The Cross and Upper High Street

These two postcards feature bustling scenes of activity from the tram era. In the top view the pedal-powered cart belongs to Joseph George Hunt, a fishmonger based at 37 High Street. In the bottom view to the right of Stead and Simpson are the premises of Lawleys, china dealers, who appeared in the local directories from 1921. The Upper High Street had been widened around 1903 to facilitate the new tramway system and thus the buildings on the right were recent additions to the local scene.

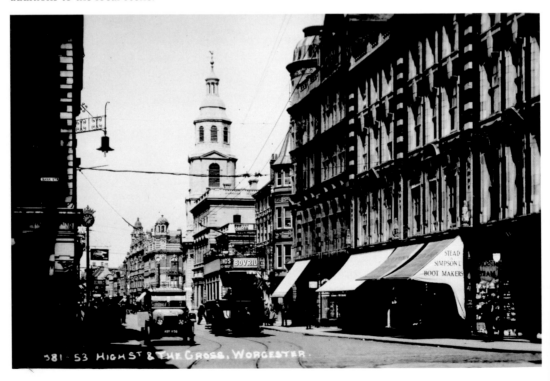

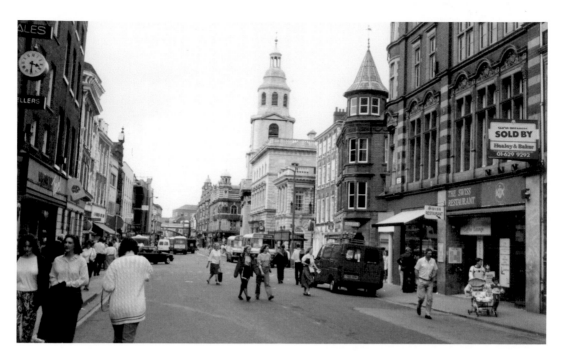

The Cross and Upper High Street

The older view is from the early 1990s. This area of the High Street had yet to be pedestrianised. Pedestrian-only zones first made their appearance in the High Street back in the late 1970s with an experimental area in front of Boots and Debenhams. Enthusiasm for pedestrian-only zones gradually increased during the 1980s and now they are considered *de rigueur*. Pedestrian-only zones always seem to need oversize trees for some strange reason and consequently views of historic buildings become obscured.

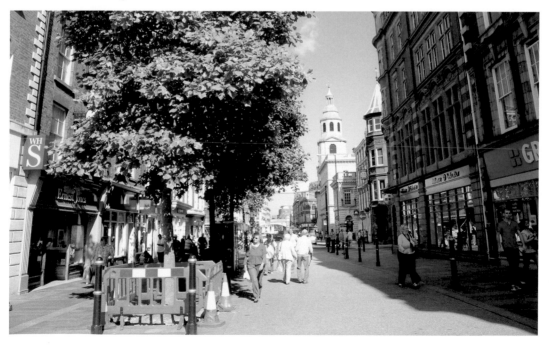

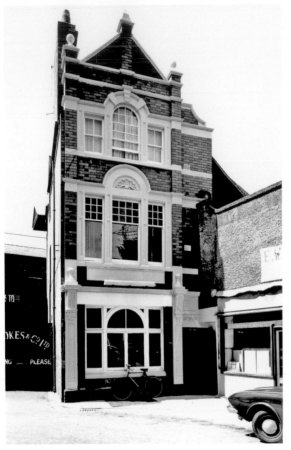

Berkeley Arms, Bank Street
A typical city-centre public house pictured on 23 August 1967. Next door is the premises of Stokes and Company who were well-known basket manufacturers. The Berkeley Arms was operating as a public house from at least 1860 when T. Townsend was the licensee. Although no longer a public house this architecturally interesting building has been incorporated in the CrownGate retail development. The view taken in 1993 shows Bank Street as viewed from the High Street.

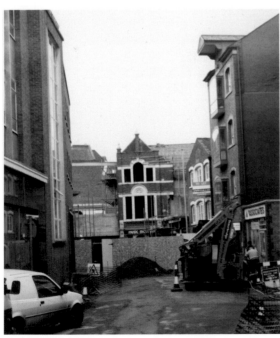

High Street looking South

The old view is from a stereoscopic card and probably dates from the early 1920s. The shops on the right include Johnson Brothers (dyers), Frederick Cooper (hairdresser), William Rayner (furrier), and Smith & Andrews (dentists). By the mid-1990s this was a radically different scene and old traditional shops have been replaced by national chain stores. But even national names can disappear and Woolworths are now no longer a feature of the British high street.

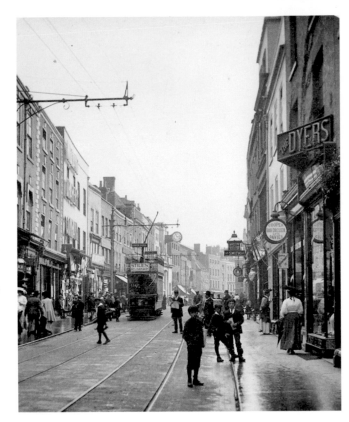

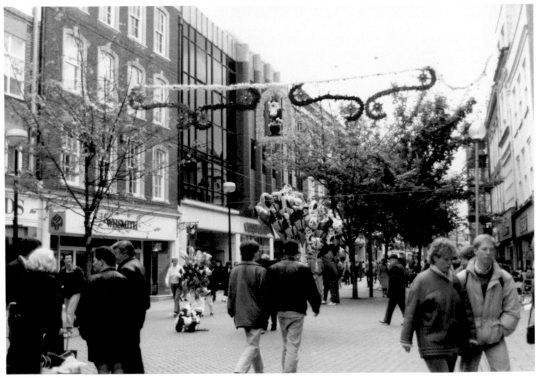

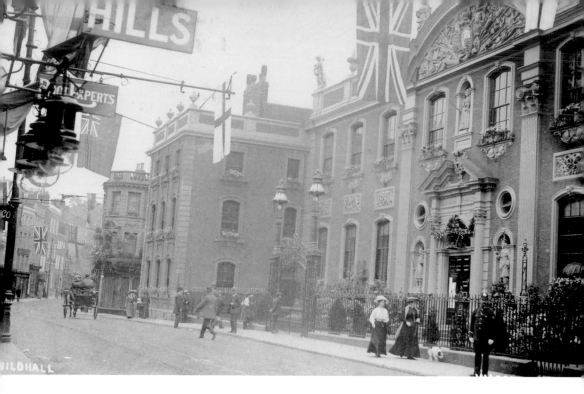

Guildhall, High Street looking North and South

The old postcard view was franked in July 1911. The flags are out for the coronation of George V that took place on 23 June 1911. Sadly all of the old buildings beyond the Guildhall no longer exist. The Guildhall now enhances a rather disjointed High Street scene where historic façades compete with their modern counterparts and the inevitable intrusive trees.

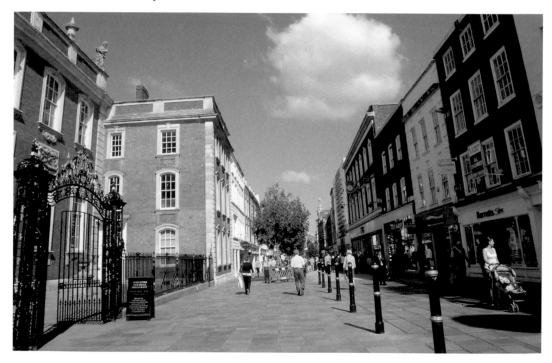

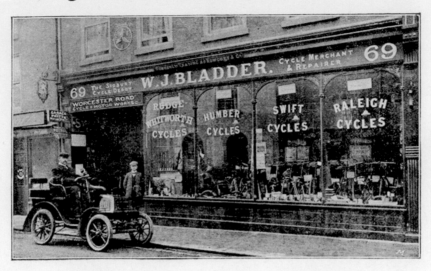

W. J. BLADDER, 69, SIDBURY,

The Worcester Garage.

Sidbury Transport Dealers

W. J. Bladder was a well-known firm of cycle dealers in Sidbury. In 1908 they were sole agents for Humbers, Swifts, and Raglans and were also manufacturers of the 'Worcester Road Cycles'. The premises, opposite the King's Head public house, were eventually knocked down in order to widen the Sidbury thoroughfare. Skellerns Motorcycles now occupy a similar location.

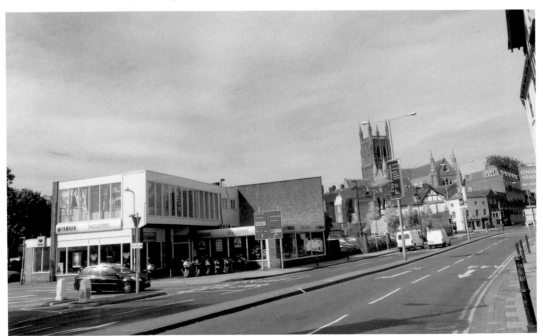

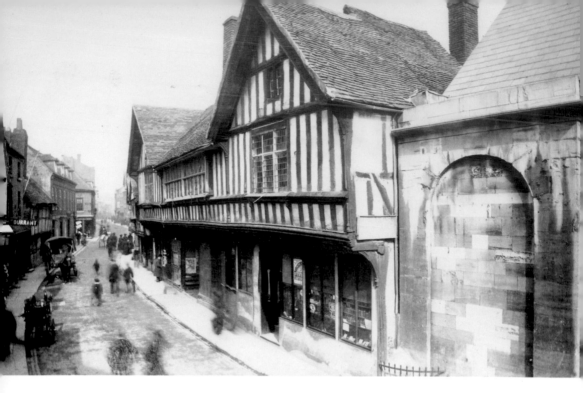

Friar Street

The Victorian view of Friar Street shows a fairly busy scene. The building on the extreme right was once part of the old gaol that became the original Laslett's Almshouses in 1867. The current almshouses replaced the original ones in 1912. The modern provision for alfresco eating and drinking has produced a bustling locale. Unfortunately there is inevitably one modern edifice that just does not blend into the historic environment.

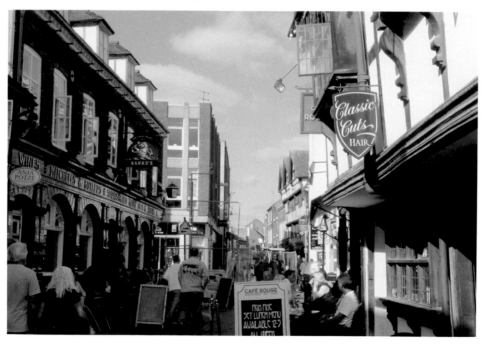

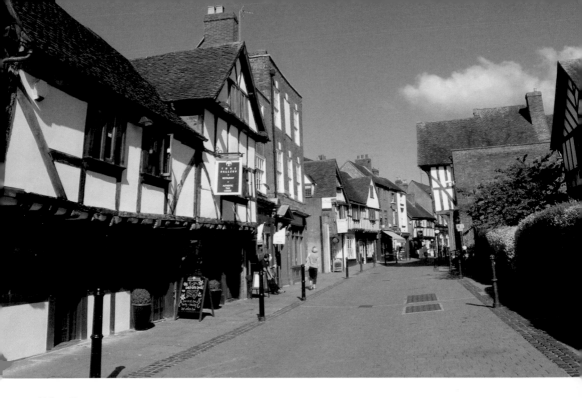

Friar Street

Further down Friar Street there are no modern intrusions of note. The Laslett's Almshouses, though still less than 100 years old, blend in well with their surroundings. Here there is a real sense of the historic Worcester. If only Lich Street had been preserved in a similar manner! The old postcard view was franked in 1905. The now-missing building, just beyond the Crown Inn (no longer a public house), was a Wesleyan mission hall in Edwardian times. It was later used by Richard Cadbury as a Welcome Mission.

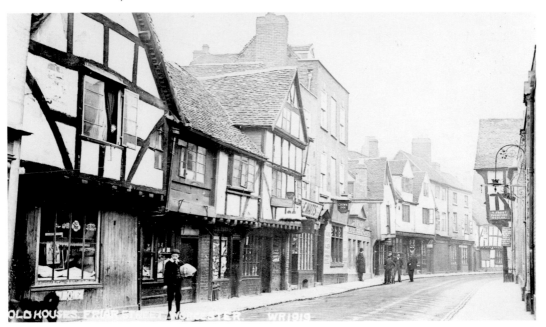

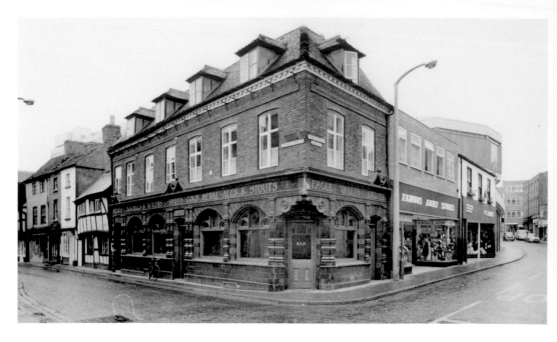

Eagle Vaults, Friar Street and Pump Street

The older photograph was taken in 1968. The Eagle Vaults has a magnificent tiled frontage that probably dates from the late Victorian period. Also of merit are the decorous sandblasted windows. The building itself is considerably older (probably late seventeenth century) and has been an inn for well over 200 years. In 1779 it was known as Young's Mug House and was also called the Volunteer between 1814 and 1817. After that it became the Plumbers Arms before being given its current name around 1859.

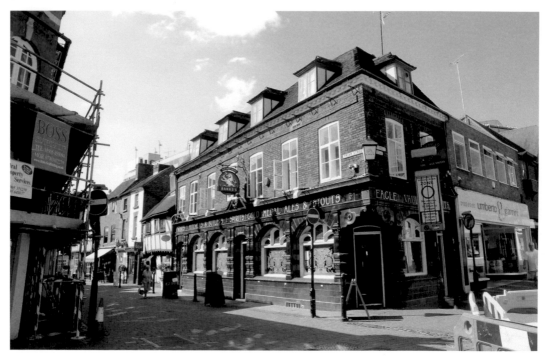

Shambles Ironmonger's

Although the old postcard was franked in 1909 the photograph would appear to be late Victorian. J. & F. Hall were well-known local ironmongers and were in business at this location prior to 1840. The building itself was probably built around 1600. Its demolition, in the mid-1960s, has to be viewed as an unforgivable act of civic vandalism. Today St Swithun's church has a far less interesting neighbour.

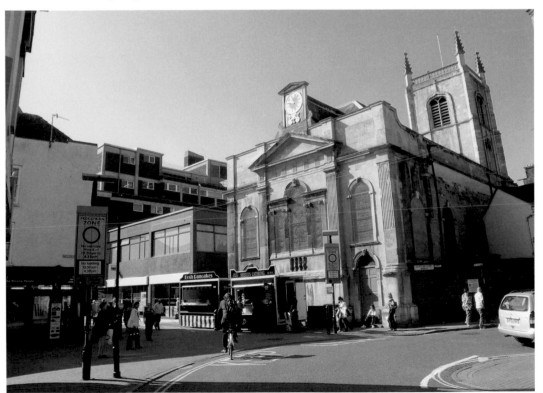

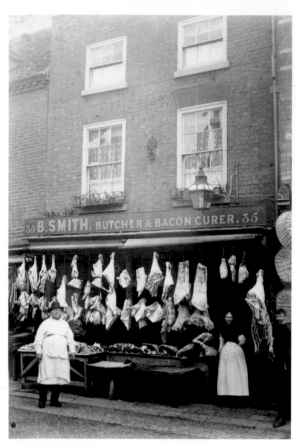

Shambles Butcher's

The fine cabinet photograph was taken by Richard Wingfield around 1886. Benjamin Smith was situated at 35 Shambles between around 1855 and '93. No less than eighteen butchers were listed in the Shambles in *Littlebury's Directory* for 1879. The printed postcard dates from around 1904 and shows the butcher's shop formerly occupied by Smith on the extreme right (the protruding lamp is clearly visible). Alfred Brewer had replaced Smith and was *in situ* around 1895 to 1908. Opposite Alfred Brewer is the well-named Butchers Arms (the licensee was Harry Thomas in 1904). The black and white building beyond the Butchers Arms was also a butcher's shop at one time.

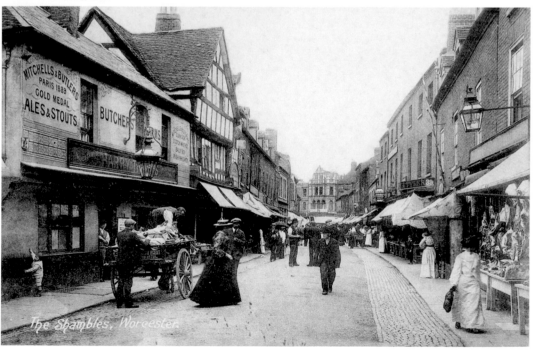

The Shambles, Worcester.

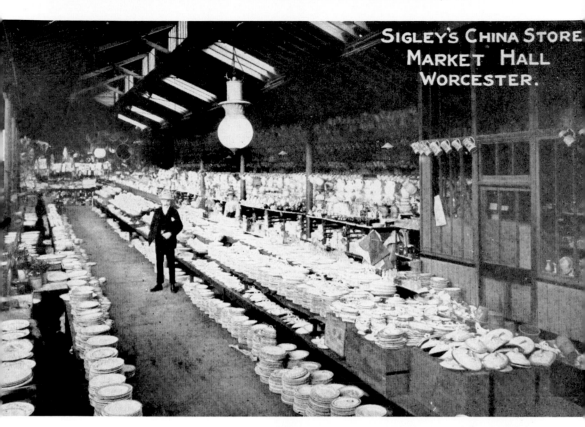

SIGLEY'S CHINA STORE
MARKET HALL
WORCESTER.

Shambles

Sigley's China Stores were based at 96 High Street but also had an extensive display of goods within the Market Hall. Albert A. Preece was the proprietor and he was an agent for Royal Worcester. They boasted of supplying innkeepers upon the most moderate of terms. The postcard was used by Sigley's in 1907 in order to inform a customer in Evesham of the despatch of their order via the Midland Railway. The Shambles nowadays is rather living up to its name. It is an incongruous mixture of the old, the new and the nondescript.

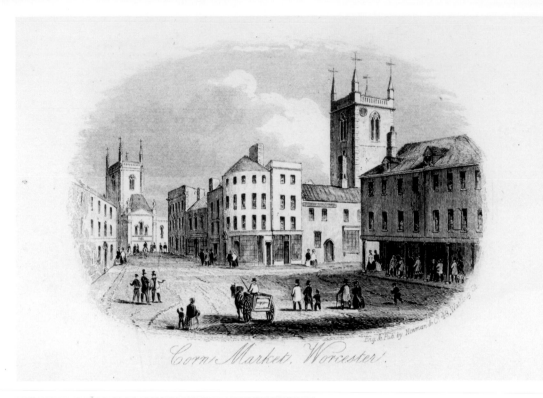

Corn Market, Worcester.

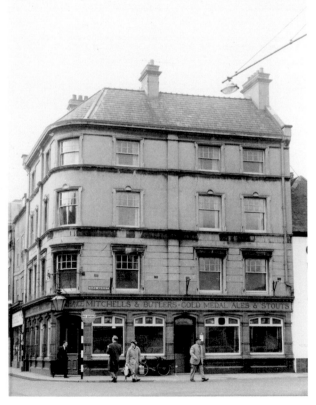

Corn Market

This was the principal market place for grain for several centuries. In 1840 this was described as a large, nearly square area hosting a weekly market on Saturday afternoons. On the right of the engraving is the Corn Exchange building (demolished in 1845 and replaced by the Public Hall [built in 1848/9] that was itself demolished in 1966). This location then became a car park. Back in 1981 the Worcester Market moved from the old Sheep Market to the Corn Market car park. It operated on Fridays and Saturdays and included my own pet stall. The Royal Exchange photograph was taken in 1961.

Corn Market

Old St Martin's, completed in 1772 at a cost of £2,215, is a beautiful church and well worth a visit. The stained glass windows are particularly fine. The Corn Market today is a busy location and the public houses seem to be thriving. Fortunately this remains a location of largely historic and interesting buildings. If the open-air car park could be replaced with a development of merit then the Corn Market could be improved still further.

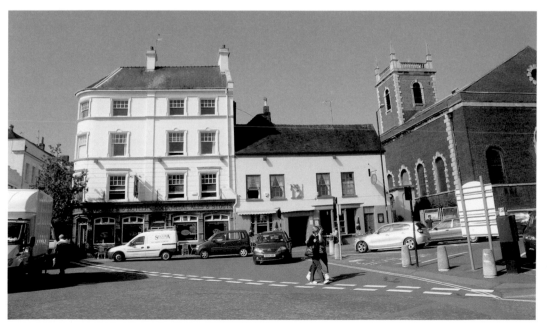

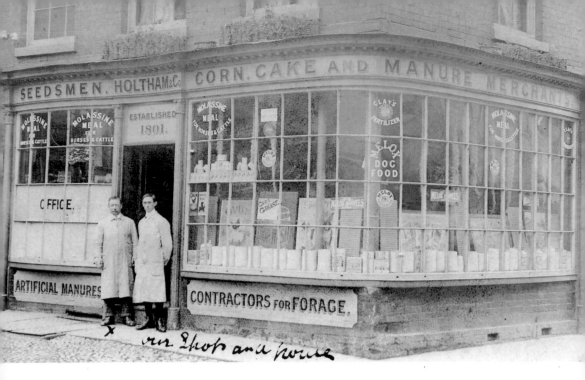

vu Shop and house

Corn Market Corn Merchant

J. W. Holtham and Company, established in 1801, was another well-known local business. Their trading name was continually used by subsequent owners until a more recent change of use. The old postcard view was franked in 1907. The writer was Mr Preece, the then-owner, who was going to Weston-super-Mare for his August holiday. The frontage of the shop looks basically the same today. New Street still maintains a largely traditional and historic environment.

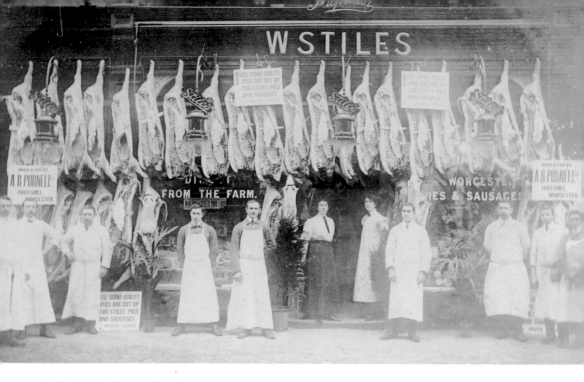

St Swithin's Street Butchers

The northern side of St Swithin's Street was demolished in the late Victorian period (due to road widening) and replaced with the contemporary terrace of buildings. W. Stiles were situated on the northern side of St Swithin's Street close to the junction with The Cross. Stiles were at this location between at least 1896 and 1912. They were supplied by Alfred Bevan Purnell, who farmed at Warndon Court Farm and Trotshill Farm. Although there are now no butchers in the Shambles there is at least one to boast of in St Swithin's Street.

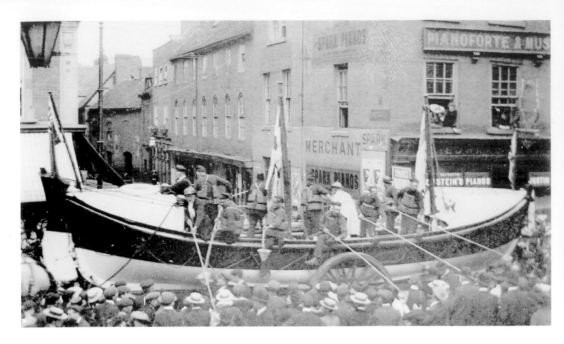

Lifeboat Saturday

For many years Worcester held an annual lifeboat procession and this one features the Weston-super-Mare lifeboat and crew in 1905. In the background, at the junction of High Street with Church Street, is the music shop belonging to Edward Spark. The buildings visible in Church Street housed the well-known stationers and printers, Deighton and Company, and also another long-lost public house, the City Arms. Barclays Bank now stands close to the site occupied by Edward Spark (demolished for widening of the High Street). Church Street is now bereft of older historic buildings with the exception of the church itself.

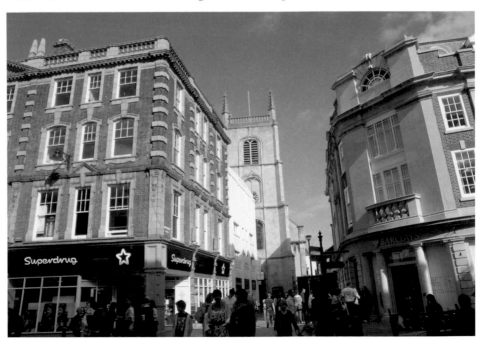

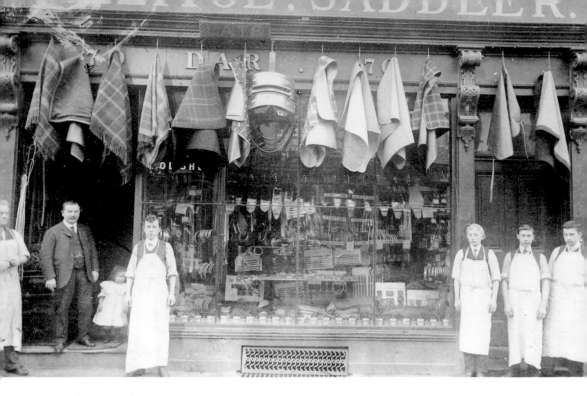

Broad Street Shop

Aaron Sillitoe, saddler and harness maker, was situated at 70 Broad Street. He is pictured with his staff around 1906. Gents' and ladies' riding saddles were made on the premises and Sillitoe boasted the largest stock of saddlery in the city. However, Sillitoe had disappeared from the local directories by 1916. First Choice, the travel agents, now trade from this building.

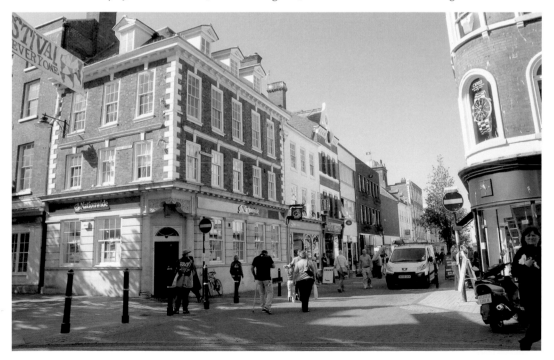

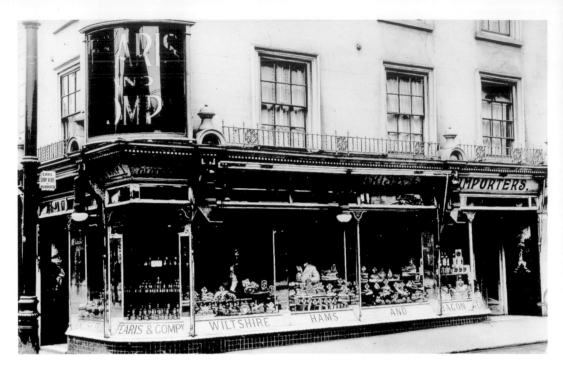

Foregate Street Shop

The business of Fearis and Company was located in the Foregate, at the junction with Angel Street. It would appear that they moved from premises in Mealcheapen Street around 1919. This edifice was an important part of the essentially Georgian line of buildings that extends from the top end of the High Street to The Tything. Why it was allowed to be demolished is a complete mystery to me. Perhaps one day a suitable edifice may be erected at this important location.

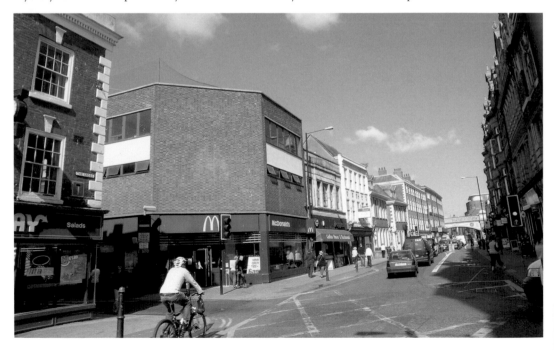

The Butts

Over the last twenty years the character of The Butts has changed greatly. In the modern photograph the prestigious Magdala Court apartment complex dominates and modern industrial units lie opposite. Beyond Magdala Court further new development is taking place on a site previously occupied by old-fashioned shops that were allowed to deteriorate to the point that they were beyond repair. The photograph taken in 1993 shows part of the future site of Magdala Court in the foreground while the area in the background will shortly become the new £60 million Worcester Library and History Centre.

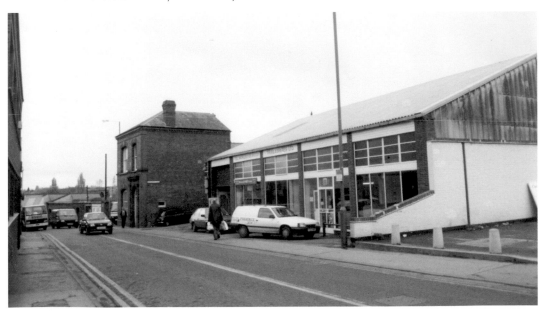

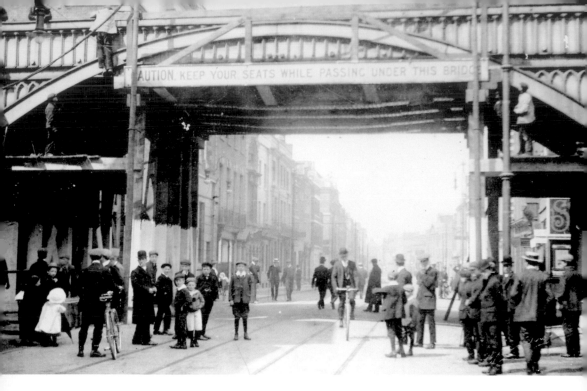

Foregate Street Bridge

The old view is by Percy Parsons and features maintenance work or refurbishment of the railway bridge presumably around 1920. Both photographs illustrate well the fairly intact Georgian linear development of the western side of Foregate Street. Unfortunately the building of the Odeon Cinema, which opened in 1950, resulted in the demolition of the Silver Cinema that had been sited within a building constructed in 1835. Thus a new building, in modern streamlined style, came to share Foregate Street with traditional Georgian neighbours.

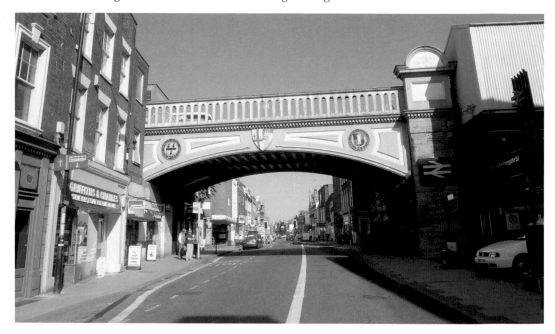

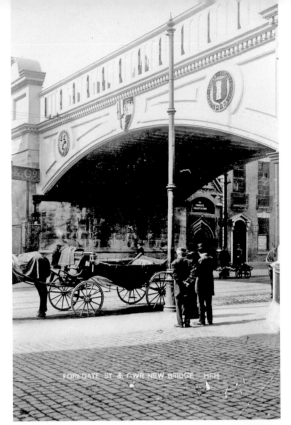

Foregate Street Bridge

In the foreground of the old postcard is cab No. 33. Beyond the bridge are the premises of the Foregate Toilet Saloon and the Cannock Chase Coal and Coke Company. Unfortunately this is another example of old Georgian style buildings being replaced by modern buildings of inappropriate design.

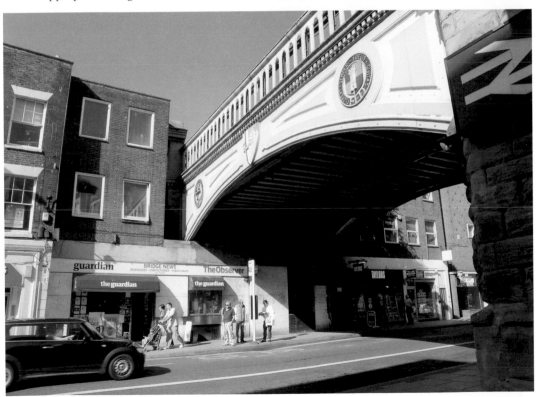

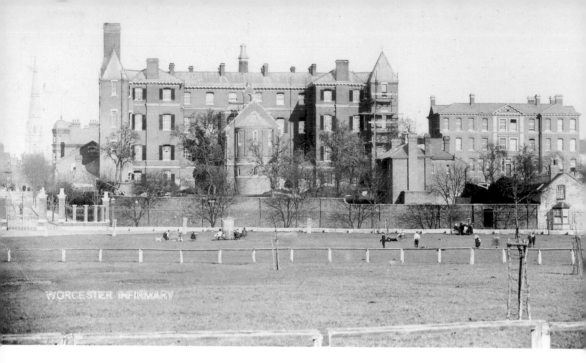

Worcester Royal Infirmary

In the old postcard view, franked in 1908, the full majesty of the Georgian building designed by Robert Keck can be appreciated. Subsequent add-on development during the twentieth century however, rather ruined the appearance of the Infirmary. Keck's buildings are now to form the historic base for a new Worcester University campus. This is a fine project but everyone I know is wondering where the necessary large car parks are which are surely needed to accompany any such development.

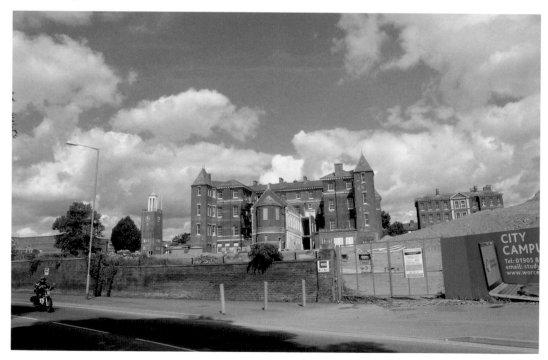

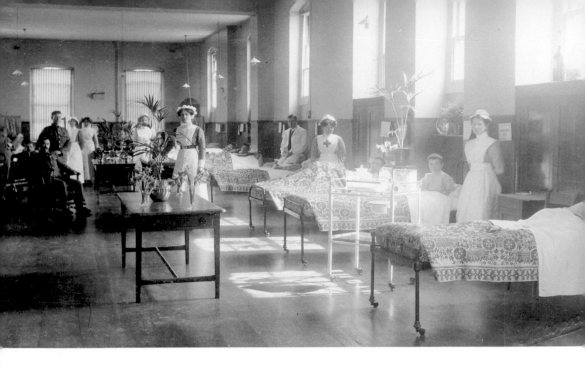

Worcester Royal Infirmary

The old postcard view by Parsons shows the Men's Medical Ward on Alexandra Day. This was named after Queen Alexandra, the consort of King Edward VII, who thought of the idea in 1912 in order to raise funds for hospitals. Fund raising for the new £90 million campus is on a much larger scale than those for the £32,000 raised by the first Alexandra Day in London in 1912. Around £55 million will be forthcoming from central government, the regional development agency, and HEFCE (the Higher Education Funding Council for England). The new campus will include a large open public square, a multi-use performance and conference centre, and residences for over 400 students.

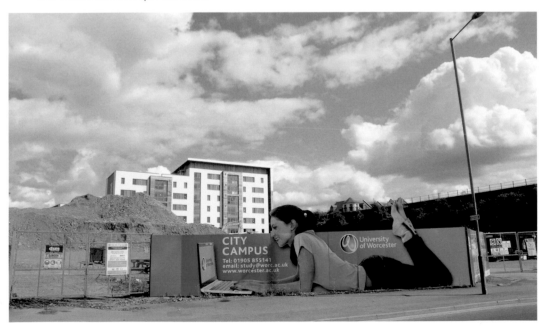

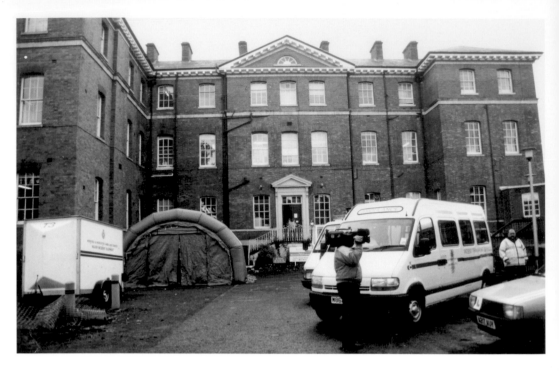

Millennium Floods

The disastrous flood brought the television crews to Worcester on 2 November 2000 as the Royal Infirmary had to be evacuated. Pitchcroft was already strictly out of bounds. The height of the flood was around seventeen feet and eight inches above summer level so making it one of the worst floods in the history of Worcester (the famous flood of 1947 was of a similar magnitude).

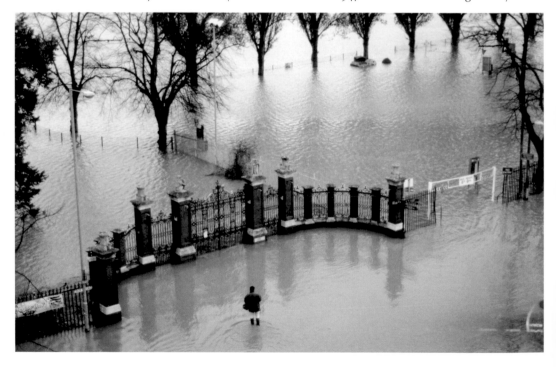

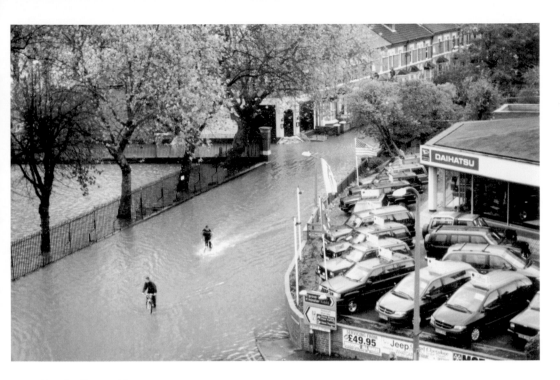

Castle Street Change

The 2000 flood scene of Severn Terrace was taken from the Royal Infirmary (as was the previous photograph of Pitchcroft). The car showrooms largely escaped the effects of the flood but did eventually become a victim of economic recession. A new use now awaits this prime site, as Castle Street and Croft Road become hosts to the new university campus.

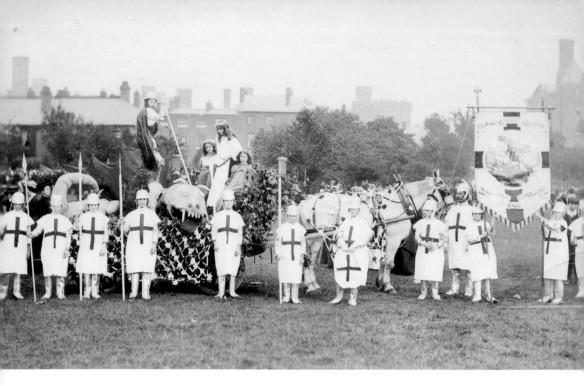

Pitchcroft

In the early twentieth century many events were traditionally staged at Pitchcroft. Above can be seen a postcard by George Colwell showing a depiction of 'St George and the Dragon' on a Lifeboat Saturday in October 1909. In the background the outline of the city gaol and royal infirmary are just discernible. Below is Empire Day in 1917.

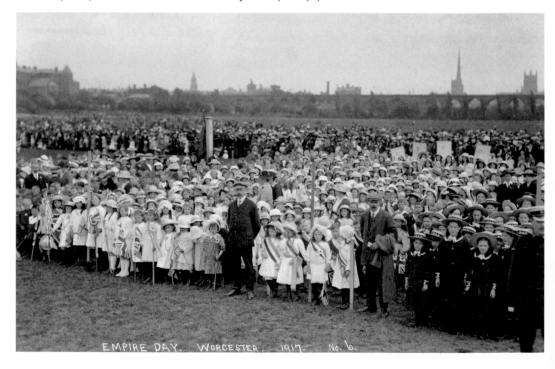

EMPIRE DAY. WORCESTER. 1917. No. 6.

Pitchcroft

Nowadays Pitchcroft mainly stages horse racing but other events are also held and fun fairs make an occasional appearance. Racing has been held on Pitchcroft since the days of Charles II. Interestingly, prior to 1899 the citizens of Worcester had no right to roam at will within Pitchcroft although they were various footpaths for the ferries. These photographs were taken during the Worcester Festival in August 2009.

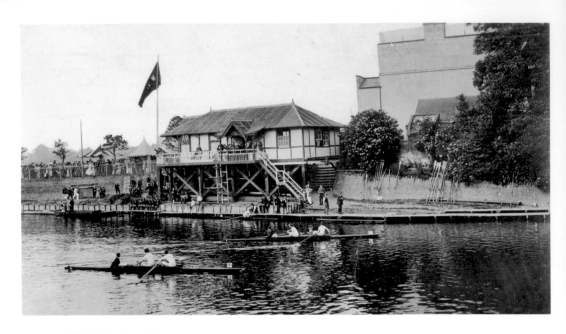

Rowing Club, Pitchcroft

Worcester Rowing Club was formed in 1874 but there were many other clubs before this date and organized rowing races were arranged over 200 years ago. The old postcard was franked in 1915 and also shows the rear of the grandstand. The late nineteenth-century timber-boarded clubhouse was severely damaged by fire following an arson attack in the spring of 1996. However, it has been rebuilt in the same basic form and was adapted for use as a fitness centre. The Worcester Rowing Club possesses large and impressive facilities close by.

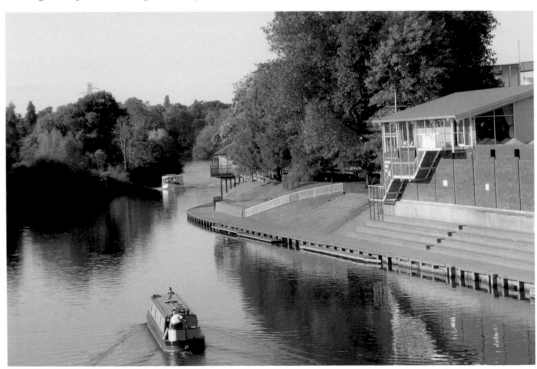

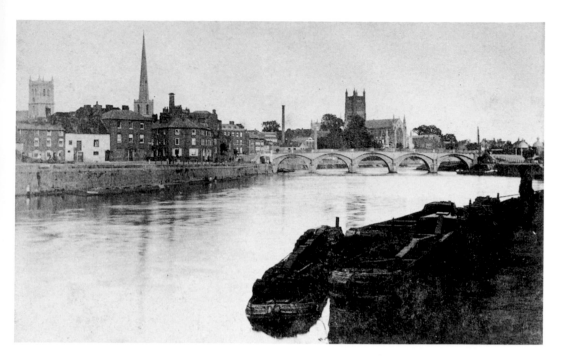

Worcester from the Railway Bridge

The old view is from a stereoscopic card by Francis Earl that would appear to date back to at least the 1860s. North Quay has changed considerably since then. The original railway bridge was built in 1860 but the current bridge dates from 1904. The modern view was taken from the Sabrina footbridge. Taking photographs from this bridge is not as easy as you would think! Because this is a suspension bridge each pedestrian/cyclist causes the bridge to bounce a little. The bridge is named after the river goddess, Sabrina.

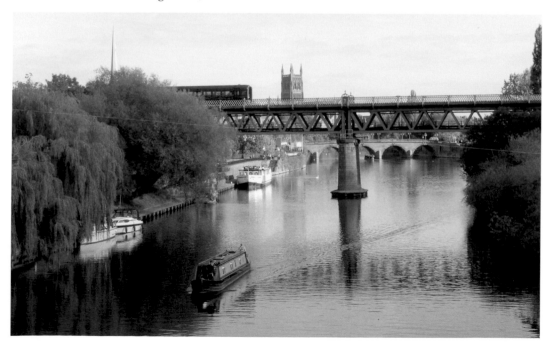

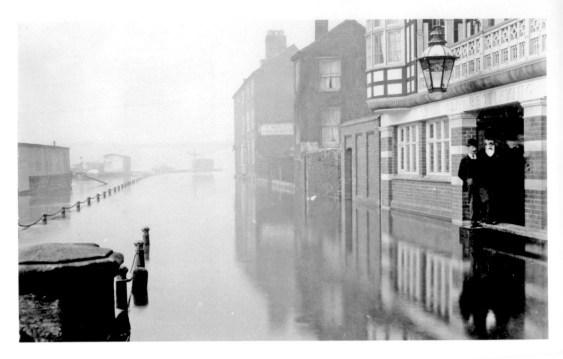

North Quay and North Parade in Flood

Unfortunately these two superb photographs are undated. The above photograph portrays a flood from around 1900. Beyond the newly rebuilt Old Rectifying House (rebuilt by Bromage and Evans) are several buildings that had disappeared from the local directories by 1908 (including Thomas Wintle, stone and marble mason). In the photograph below the Hope and Anchor public house (in Newport Street) can be seen behind the Old Rectifying House. This might be the flood of December 1910. The 'Butts Spur' railway line can be clearly seen.

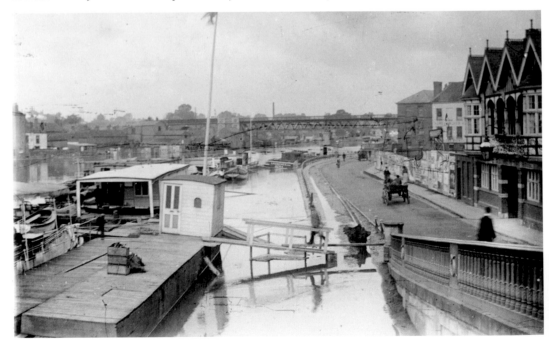

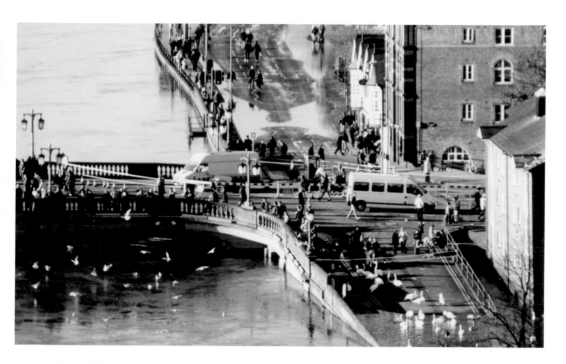

Old Rectifying House

The older photograph was taken from the cathedral on 4 November 2000. St John's was virtually cut off from the rest of the city but fortunately the Army were on hand to help ferry pedestrians across the bridge and a heavily-flooded New Road. The Old Rectifying House appears frequently in flood photographs of Worcester and always seems to be teetering on the edge of potential devastation at the time of flood.

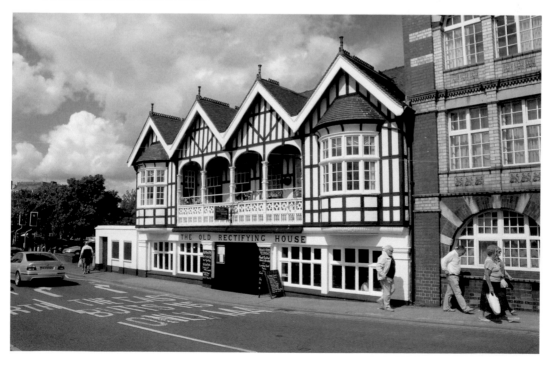

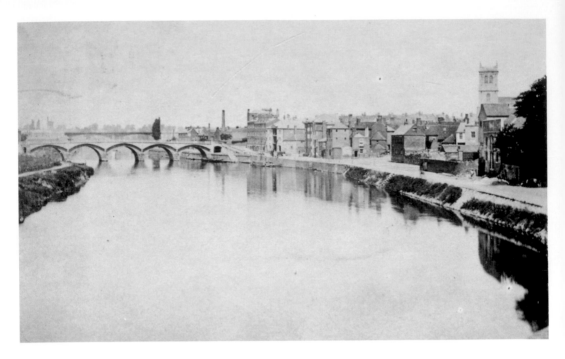

The Bridge, South Parade, and South Quay from the South

The old view is from a stereoscopic card by Francis Earl that would appear to date back to at least the 1860s. There is a curious lack of activity on South Quay that suggests Earl took the photograph very early in the day or maybe on a Sunday. South Quay has totally changed from an area of commerce to an area for tourism.

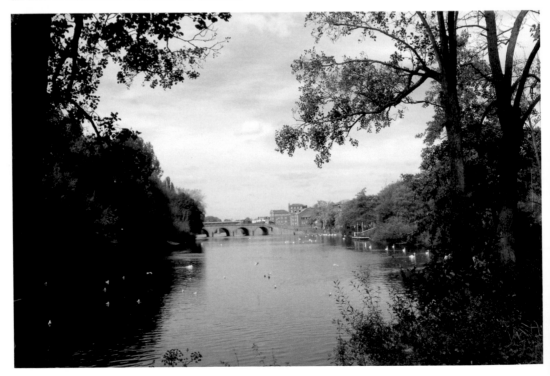

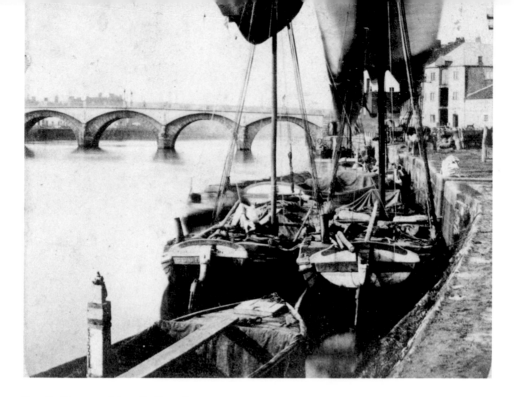

South Quay and South Parade

The old view is from a stereoscopic card that would appear to date back to at least the 1860s. Beyond the trows numerous carts can be seen on the quayside. There is also a crane of some description. The warehouse in the background was later occupied by Charles S. Phillips, corn merchant (see old photograph on page 42). It later became The City Rag Stores and was subsequently demolished. The new view shows the only remaining old buildings on South Quay. The scaffolded building, Gascoyne House, was once the hop warehouse of Henry Firkins. George Gascoyne, a well-known hop and seed merchant purchased the building in 1915.

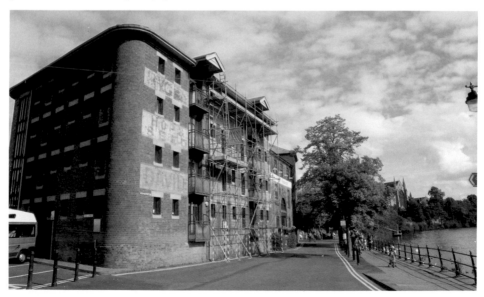

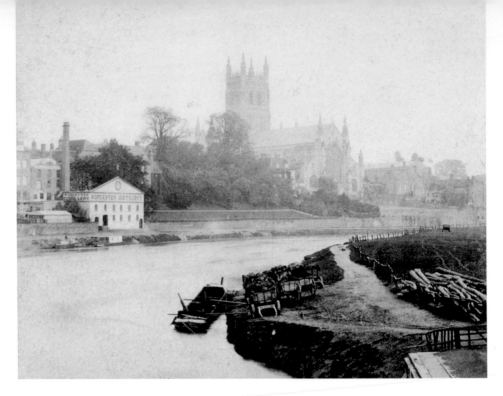

South Quay and the Cathedral from Bromwich Parade

The above view (from around 1870) is from a stereoscopic card by Francis Bedford, a renowned national photographer. The carts in the foreground are loaded with what appear to be large logs of wood. The view below is from a carte-de-visite that was purchased in Worcester on 10 January 1873. The detail is virtually the same but there is no sign of the wooden fence that can be seen in the foreground of the view above.

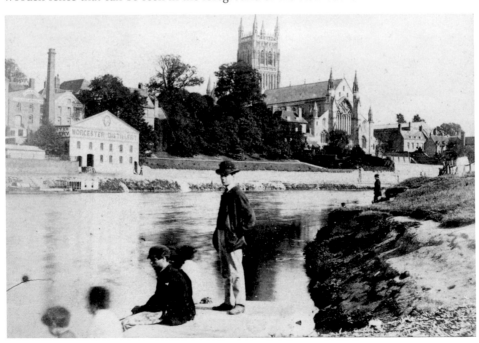

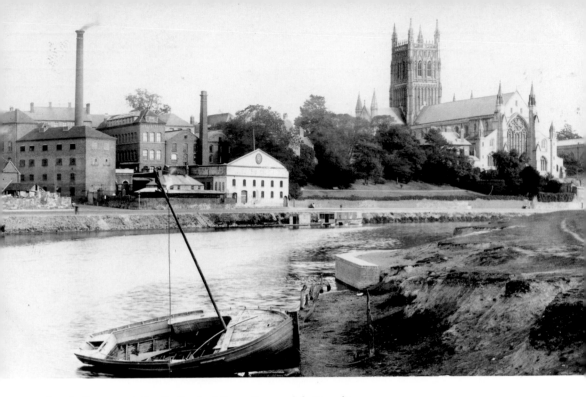

South Quay and the Cathedral from Bromwich Parade

The old postcard was franked in 1911 and shows a scene not much changed from the 1870s. Below the distillery can be seen the premises of a boat builder, Thomas Price, who also had premises at 54 Hylton Road. The modern view was taken from the bridge in August 2009. The often derided Technical College (architecturally speaking) blends in reasonably well with its surroundings.

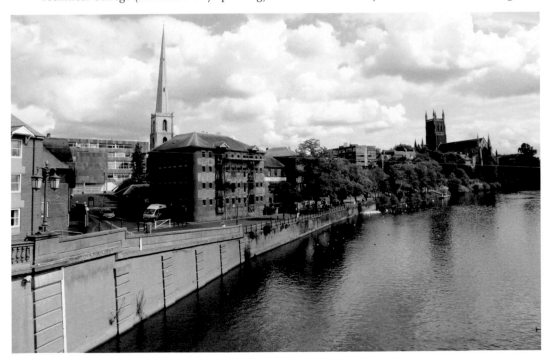

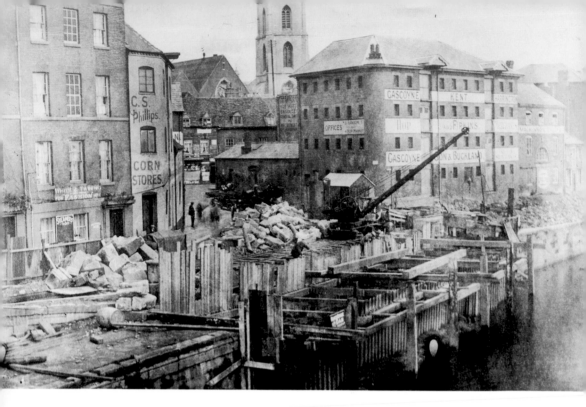

South Parade and South Quay Chaos

The old view is from 1930 and shows the busy and chaotic scene as the scheme to widen the bridge took place. In the middle foreground is Hood Street that leads to Quay Street. Beyond the houses of Quay Street the Hounds Lane School is just discernible. The new view shows the flood scene in June 2007.

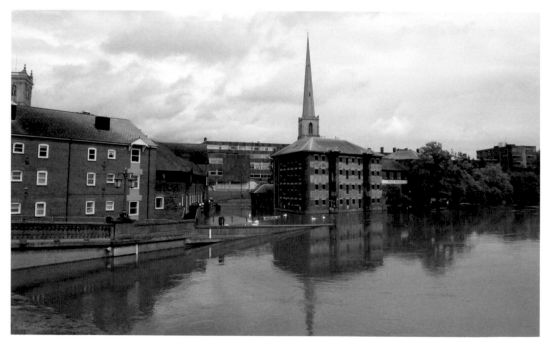

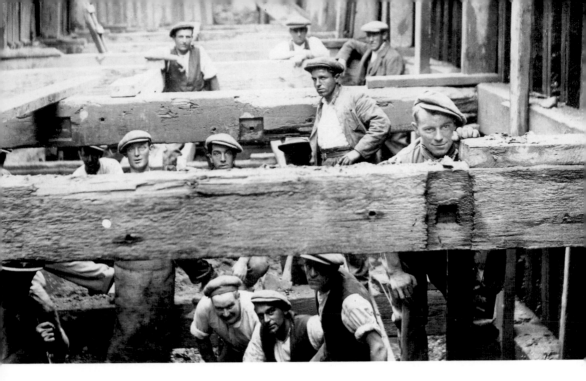

South Parade and South Quay Activity

The 1930 photograph shows workers wearing their soft safety hats. Recreational activity is now the order of the day on South Quay. The fountains that were constructed in 2000 have been a great success, particularly with young children. The Quay Restaurant is one of the few older buildings surviving in this location. For many years this building was occupied by Waldron and Company, sauce manufacturers. At one time Copenhagen Street adjoined Quay Street and South Quay.

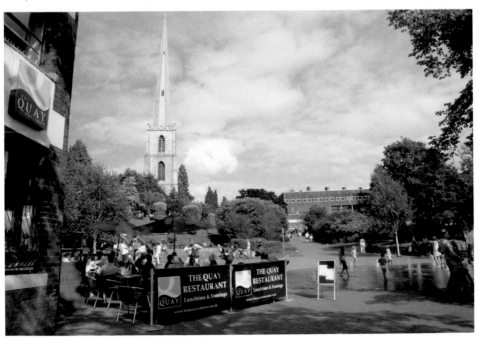

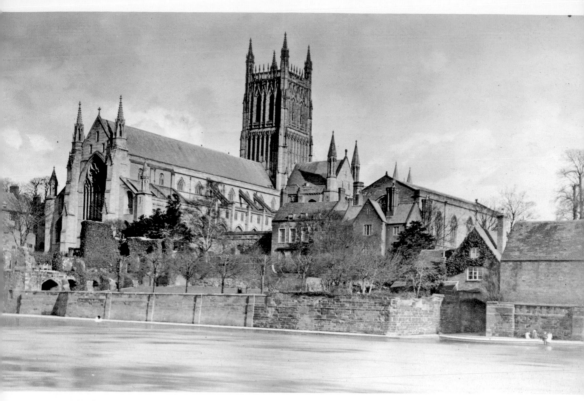

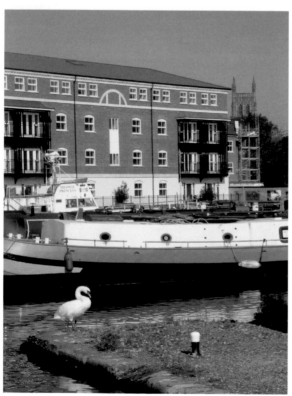

Cathedral Views

The old postcard, probably by Clutterbuck, was franked in April 1912 and possibly features the flood of December 1910. The modern view was taken in September 2008 and features the new development at Diglis Water (the next photograph was also taken in September 2008). The former Diglis Dock area is being transformed into a pleasant place to dwell and will include new facilities such as shops, restaurants, a community centre and a gym.

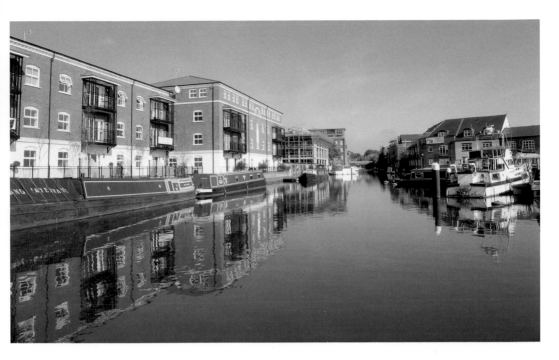

Diglis Water

According to the late local historian, Bill Gwilliam, the dock at Diglis was regarded as a white elephant for many years. It had been built in the early 1890s with the intention of making Worcester an important inland port. However, the Cardiff dock authorities who had backed the scheme only did so until they had managed to contrive better terms from the Great Western Railway. Consequently for many years the purpose of the main barges to come up the Severn to Worcester were connected primarily with the timber industry. The main company involved was W. H. Aston (Worcester) Limited. They had extensive forests at Kalvia, Finland.

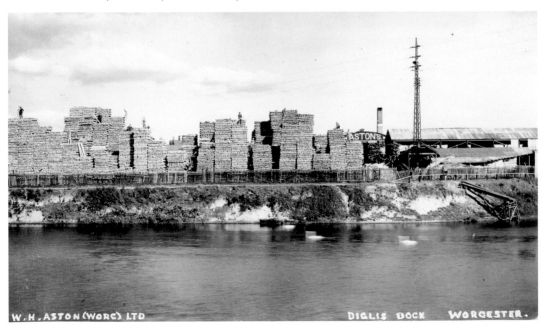

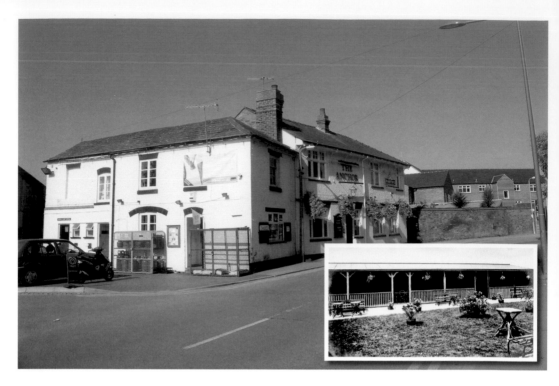

Diglis Water

A main beneficiary of the Diglis Water development will hopefully be the Anchor Inn. The opening up of the basin area to tourism and new residents will provide much new business. The Anchor Inn dates back to at least the 1850s when the licensee, William Marston, was also described as a millstone maker. A new restaurant is also planned nearby.

Inset: The beer gardens some years ago.

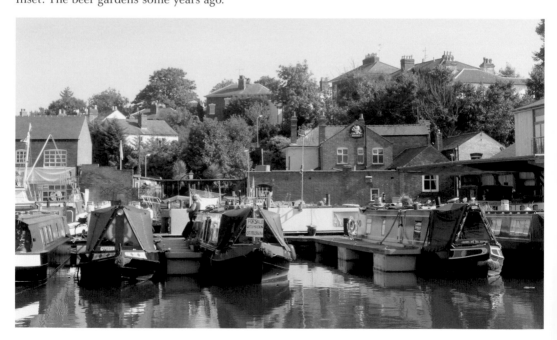

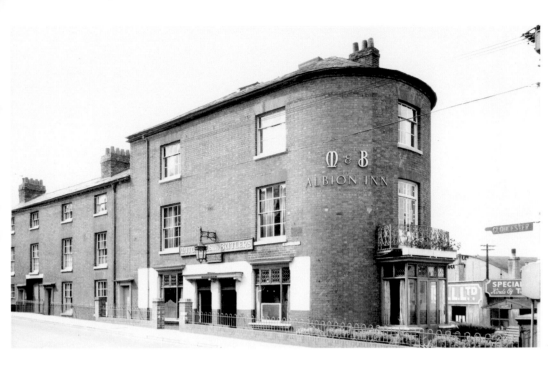

Albion Inn, Bath Road

This public house dates back to at least around 1840 when J. Sanders was the licensee. This impressive edifice has unfortunately lost the housing that adjoined it on the Bath Road. Tansell's delightfully old-fashioned premises still lie nearby. Future business prospects for the Albion look bright as it is in close proximity to the developments at Diglis Water and at the Waterside (the site of the Royal Worcester Porcelain Works).

Inset: Tram No. 2 pulls alongside the Albion Inn around 1912.

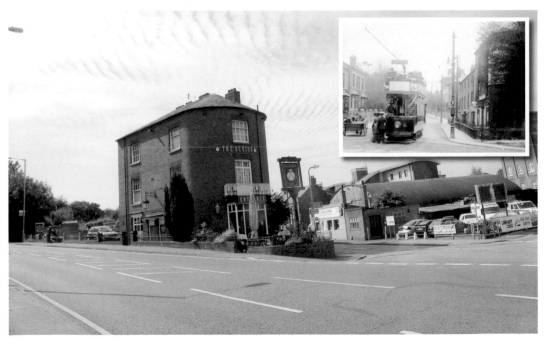

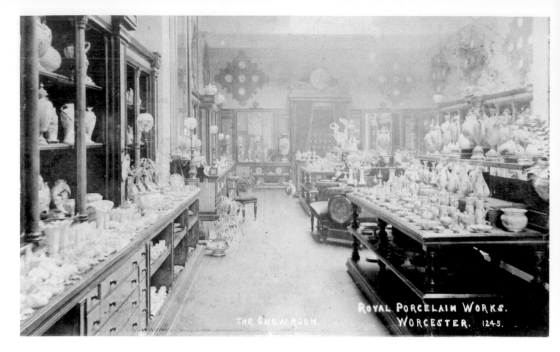

Porcelain Works

The upper photograph is an interior view of the showroom from around 1908. This fine building was the showroom of the works for many years but was latterly used as a restaurant. Its façade was used on the cover of the first guide to the works known to exist in the archives and that was published in 1853, two years after Kerr and Binns had taken over the works. A new future lies in store.

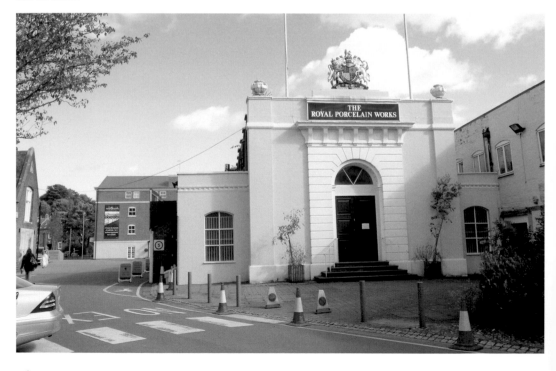

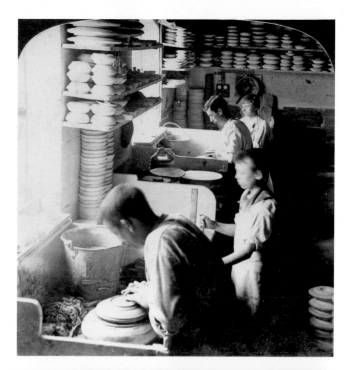

Porcelain Works

The old photograph is taken from a stereoscopic card (over 100 years old) and features the process of throwing. The man who works at the potter's wheel is called the thrower. He receives from his assistant a ball of clay that he throws upon the head of the wheel or horizontal lathe before him. He then moulds and fashions the clay accordingly. The Throwing House, designed by G. B. Ford and built in 1877, is soon to be 5,472 square feet of

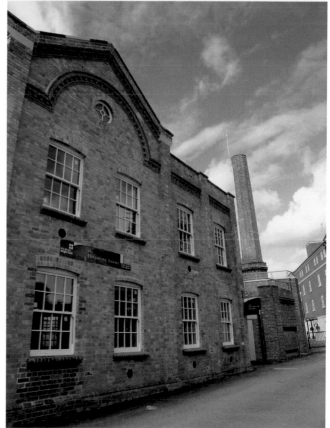

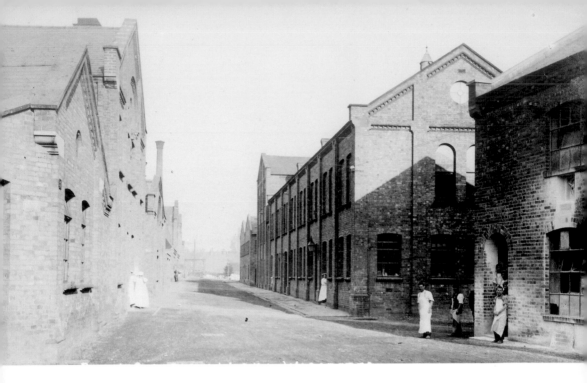

Porcelain Works

The rare view of the works dates from around 1908. The building on the right was built in 1879 and housed the original museum and the office of R. W. Binns, who ran the company, on the top floor. The recent demolition of various factory buildings revealed a similar view in September 2008. The Bone Mill can be seen in the distance.

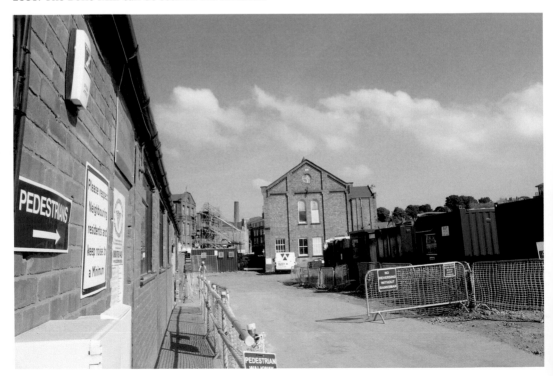

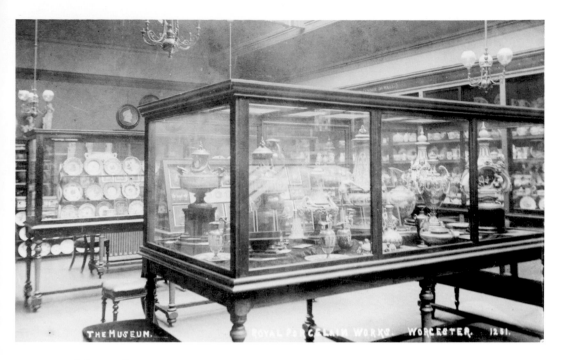

Porcelain Works

This is an interior view of the museum from around 1908. Richard Binns was greatly interested in the historical aspect of the company he ran and he bought many items that enhanced the collection. The museum also displayed many samples from the bespoke services produced during the early nineteenth century as well as fine Victorian exhibition pieces produced under the direction of Binns. A catalogue of the museum collection was written and published by Binns in 1884. The museum is now housed in the former St Peter's School building and has been greatly extended and modernised in recent years.

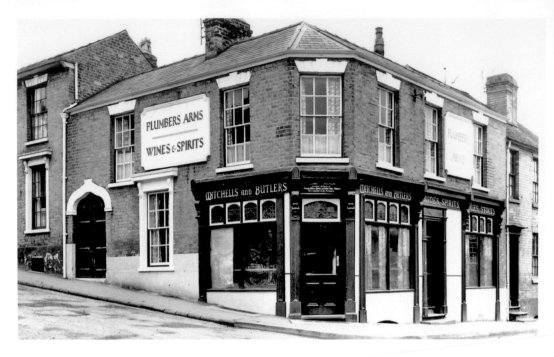

Plumbers Arms

The old view dates from 1960. This public house is situated on the junction of Cole Hill and Wylds Lane and is well over 100 years old. A local directory for 1873 lists George Tudge as the licensee of the Plumbers Arms, Commandery Street. This had changed to a listing of Mrs Harriet Tudge, Wylds Lane in 1879. Wylds Lane takes its name from the sixteenth-century owners of the Commandery. It was at one time a very rural back-road but was widened around 1863 and I would think that the Plumbers Arms was built shortly afterwards. The Plumbers Arms now serves a very cosmopolitan community.

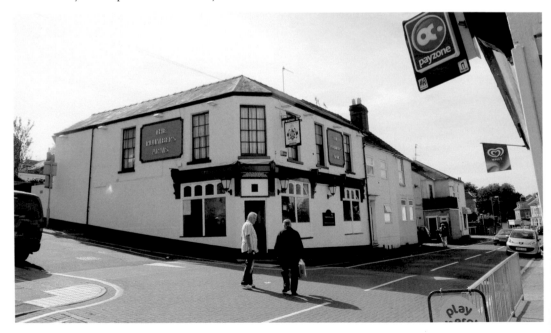

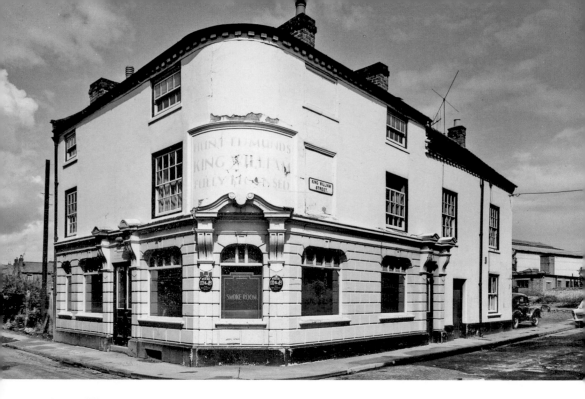

King William IV

Pictured in August 1967 the king's reign of over 100 years was shortly to end (it closed around 1970 and was demolished in 1975). King William Street has also made its exit. Both were located opposite the junction of Charles Street with Foundry Street. Foundry Street is now a bland thoroughfare but it still does possess part of the old industrial building from which its name derives, now occupied by Orillo. The owner of Orillo tells me that it dates back to 1814. Hardy & Padmore, iron and brass founders, were the well-known former occupiers.

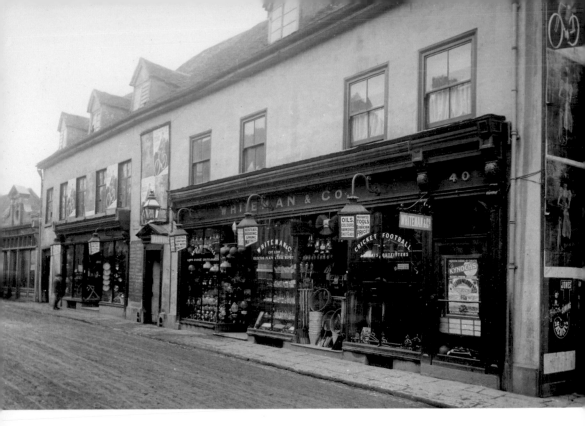

Silver Street Infirmary

Whiteman & Company, ironmongers and cycle agents, pictured around 1904 at 40/41 Silver Street (by 1908 renumbering had taken place and the address became 18/20 Silver Street). Whiteman's were still listed at this location in the local trade directory for 1955/6. In recent years this has been a Majestic Wine Warehouse. These premises housed Worcester's first infirmary for around twenty-five years from 1745. They will thankfully be refurbished as part of the current Lowesmoor redevelopment scheme.

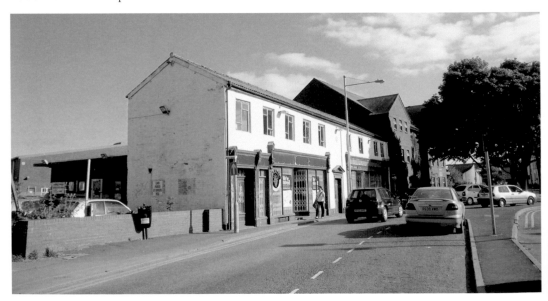

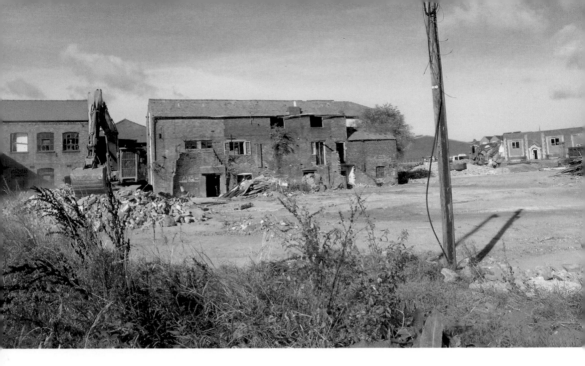

Kiln Revealed

Considering that Worcester is world famous for porcelain it is rather disappointing that there is not one intact bottle kiln remaining. However the demolition of old premises in Lowesmoor has led to a renewed sighting of the partial remains of a bottle kiln. This was sited within the Grainger Works that was taken over by Royal Worcester in 1889. Grainger's had been in the area since around 1808 but a fire had destroyed their original works in 1809 and they had to build new works on this site which adjoined the vast vinegar works complex. The older photograph shows the frontage of the Grainger factory in 1993.

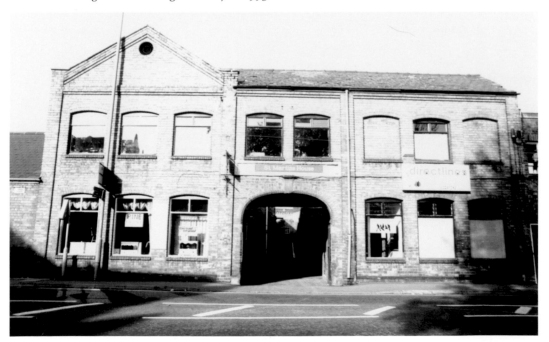

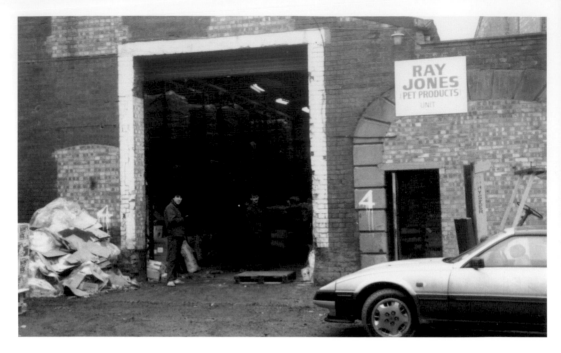

Lowesmoor Trading Estate

The estate was formed in the late 1960s by utilising the old buildings of the defunct vinegar works that had been run by Hill, Evans and Company. The buildings were in poor condition but low rentals ensured that the estate was usually fully let. My own pet food business operated from here (in two different units) for around nine years before moving to Blackpole in 1988. The pile of rubble on the left would be from my old warehouse (Unit 4) while the view follows the path that the 'Vinegar Line' railway took after it traversed over Pheasant Street. In the distance is the rear of the Territorial Army building.

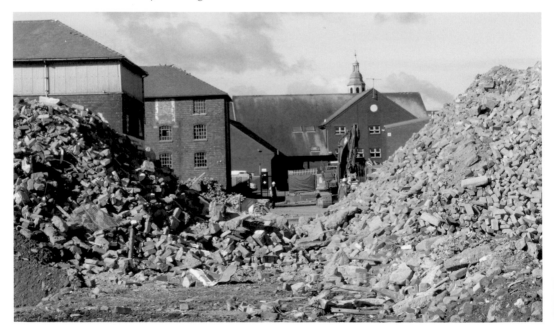

Lowesmoor Trading Estate

The 1980s view also follows the path that the 'Vinegar Line' railway took (looking in the opposite direction). The foreground is the location of where the main points were that led off to various sidings within the works. The photograph taken in September 2009 shows an unusual mock-Tudor style building that was apparently used as offices by Hill, Evans and Company. In the 1980s it was a motor repair workshop run by John Austin. Part of the cleared area in the foreground was where my first pet food warehouse (Unit 3) was situated. At one time I shared the premises with Robocraft who manufactured gnomes and other garden ornaments.

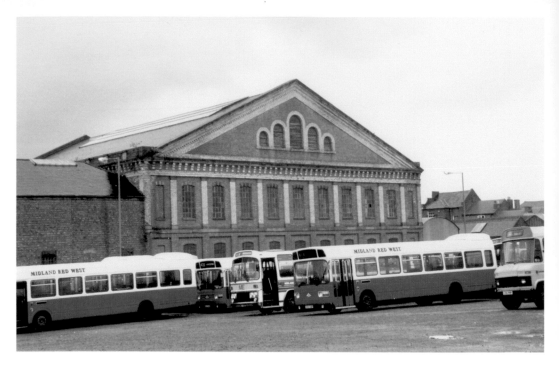

Great Filling Hall in 1993 and 2009

When this historically important building was built it had, reputedly, the world's largest single span roof (the dimensions are certainly impressive as the hall measures 160 feet by 120 feet with a height of 70 feet). Underwoods, the well-known local firm, used the building as a steel stockholding facility for a number of years. Thankfully the Filling Hall is now being fully restored to its former glory and will eventually become the new headquarters for the Territorial Army.

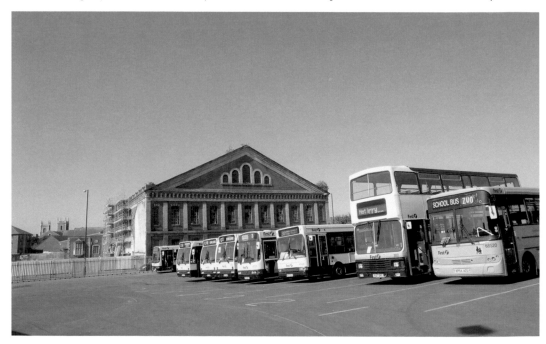

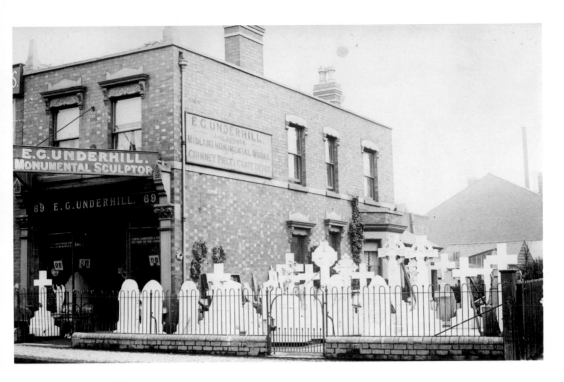

Lowesmoor Place

Edmund George Underhill was in business here for many years but had a perhaps unlikely neighbour in the West Midland Tavern that still survives today. The old postcard (franked in 1907) was personally written by Mr Underhill in the course of his business.

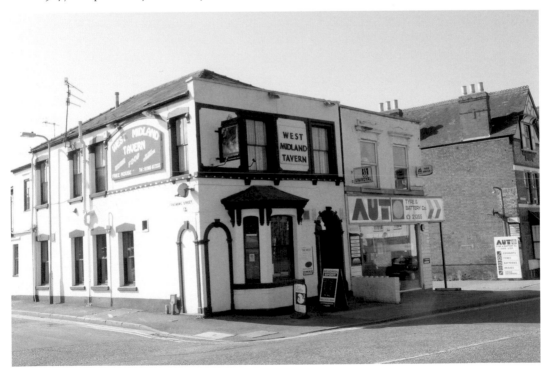

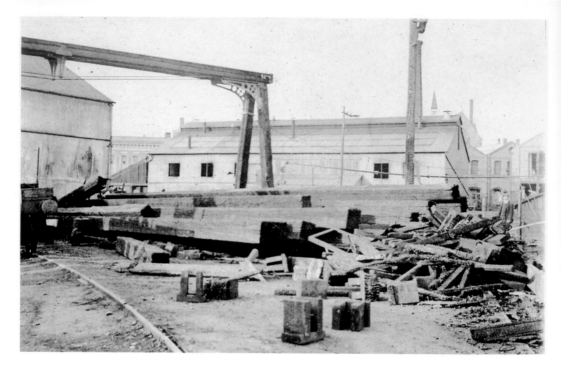

Vulcan Works

The firm of McKenzie & Holland, railway signal engineers founded in 1862, were based at the works that occupied an area of about four acres (situated on both sides of the Birmingham and Worcester Canal). In 1897 the firm boasted that it was the largest industrial institution in Worcester and employed over 600 workers. The two old views appear to depict the aftermath of a fire from around 1910. This part of the site is still in industrial use today. Cromwell Street is now a characterless cul-de-sac.

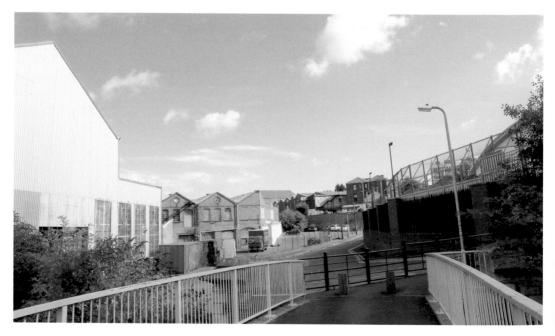

Vulcan Works

The works was connected to the Great Western Railway by a branch line known as the 'Vinegar Line' as it also served the vast Hill, Evans and Company vinegar works in Lowesmoor. The line crossed the canal close to the bridge shown below, then passed through the eastern part of the Vulcan Works, then over Pheasant Street into the vinegar works. By 1902 the vinegar works occupied around seven acres. The frontage of the Vulcan works was on Shrub Hill Road, now the location of Isaac Maddox House.

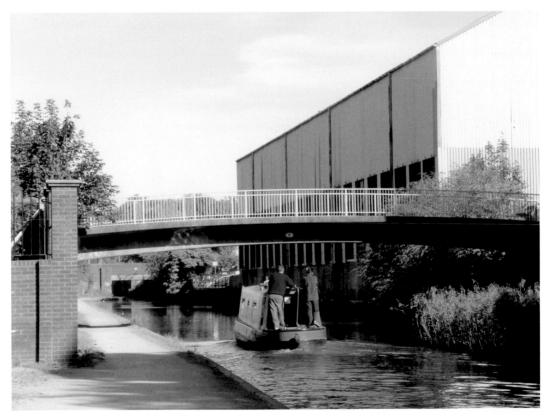

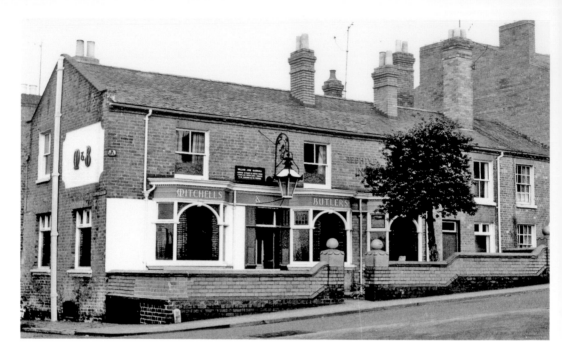

Hill Street Blues

Back in 2001, in *Worcester Past and Present*, published by Sutton Publishing, I commented that the Beehive, located on the corner of Tallow Hill and Hill Street, faced an uncertain future. There was some hope that it might have formed part of the new retail park development but that hope was forlorn. William John Marshall was licensee in the photograph taken around 1960. The Beehive had changed only slightly by 2001 and appeared to be thriving. Interestingly the only building surviving from the 2001 view is Elgar House. This unattractive edifice is regularly voted Worcester's most hated building!

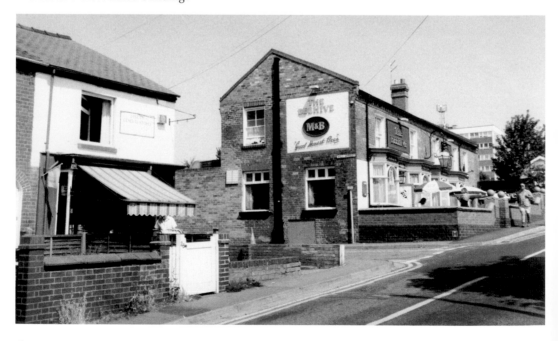

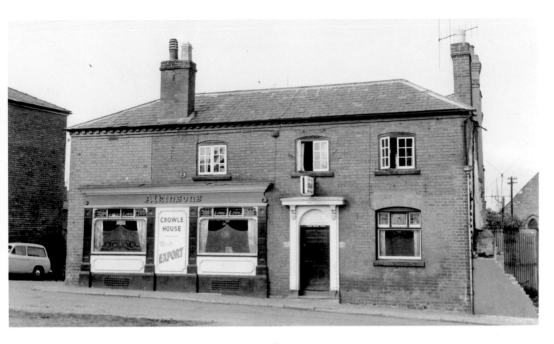

Hill Street Blues

Crowle House was also situated in Hill Street (at the junction with Lower Street). This view is from around 1962 when Frank Vincent Jones was the licensee. The building in the right background may well be the former Holy Trinity Infant School. The modern Shrub Hill Retail Park now occupies the site that was also the location of Regent Street.

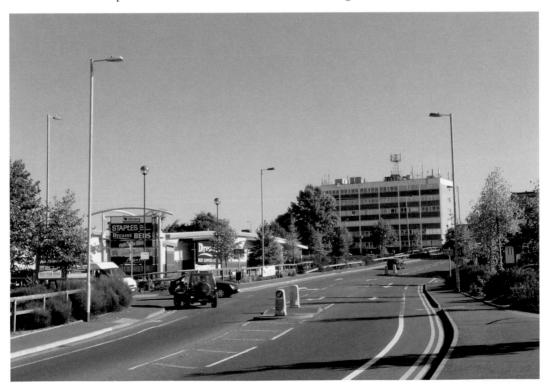

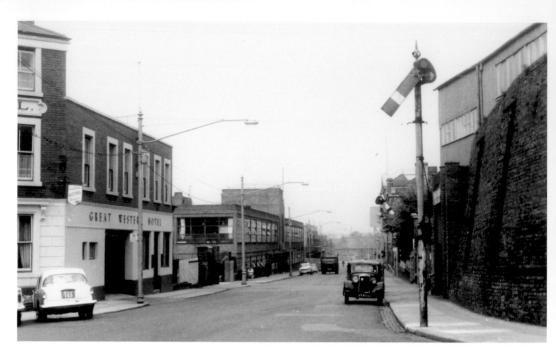

Great Western Hotel

The photograph from 1960 shows where the 'Vinegar Line' crossed the Shrub Hill Road. Beyond the Great Western Hotel, on the southern side of the Shrub Hill Road, can be seen engineering works located on the site of the old Vulcan Works. The Great Western Hotel survives today but all of its rivals have long gone and they include the Ram Tavern, the Railway Arms, the Prince of Wales, Crowle House and the Beehive.

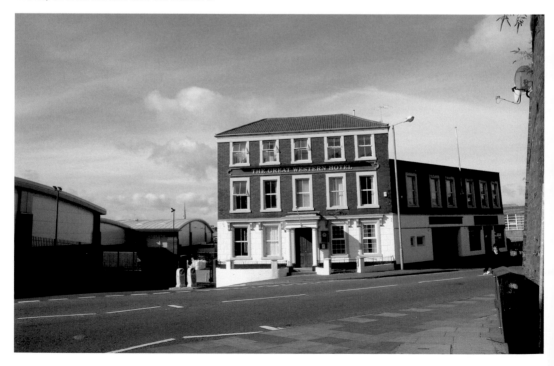

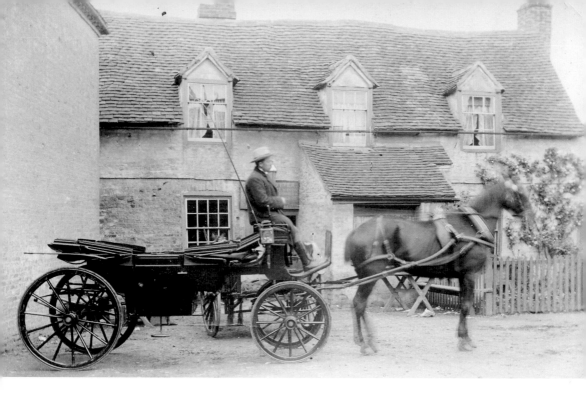

The Gun Tavern

Back in Edwardian times when George Potter was the licensee this was a fairly rural location. There was some linear development along the Newtown Road while nearer to the railway there was some industry including the purpose built factory of Locke and Company, porcelain manufacturers. They were *in situ* from around 1895 to 1915. The factory buildings still survive today, unlike the Gun Tavern, which has been knocked down and totally rebuilt.

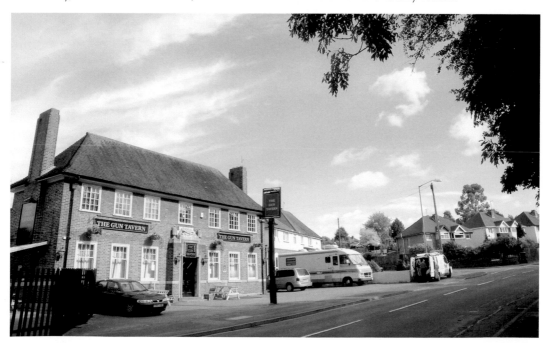

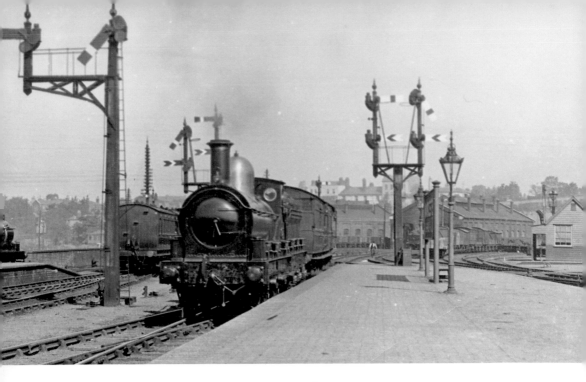

Shrub Hill Station

On the extreme left of this probably-Edwardian view can be seen a tank engine *en route* for Bromyard. The main engine to be seen is No. 427, an 0-6-0 outside frame tender engine built in 1868 at the GWR workshops in Swindon and withdrawn from service in 1917. Trains these days lack the romance of former days, I am afraid. In the far distance can be seen the white frontages of the impressive houses on Rainbow Hill Terrace.

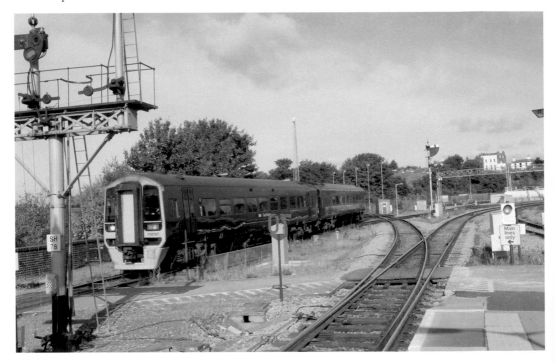

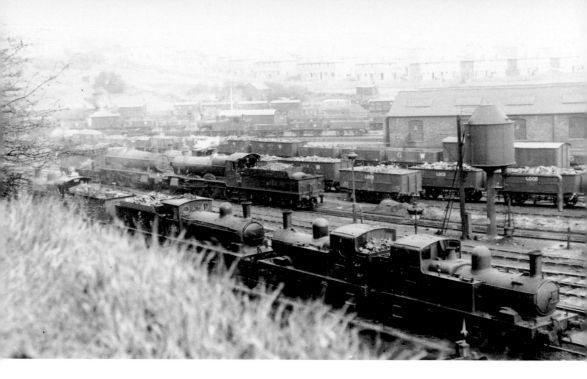

Shrub Hill Shed

Worcester was a major locomotive shed for many years and had the code of 85A. This view, taken from Railway Walk, shows the council houses of Rose Avenue in the background. Steam locomotives were allocated to Worcester until the end of 1965 although steam locomotives from other sheds continued to be seen at Worcester for some months after that. The railway operations at Shrub Hill covered a large area and initially included large engine construction works. Other forms of industry have now replaced and eradicated Worcester's glorious railway past.

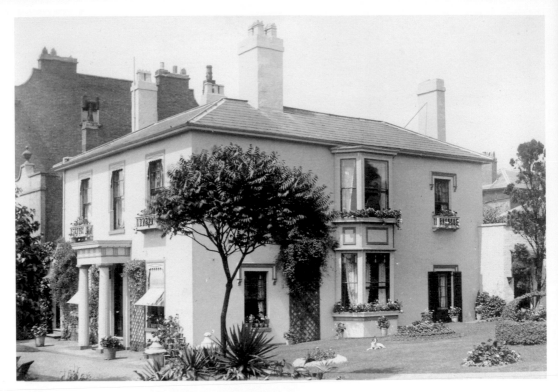

Rainbow Hill Terrace

Before the coming of the railway Rainbow Hill was an area of green fields and orchards populated by a scattering of high-class residences. Included amongst these was Marl Bank, once the home of Sir Edward Elgar. Nearly adjacent to Marl Bank, on the opposite side of Rainbow Hill (the road) was the fine Rainbow Hill Terrace. The houses located here have interesting views over Worcester (see new photograph on page 66). Rainbow Hill House is situated at the end of the terrace amidst spacious grounds. James Hayes was the owner when the Edwardian view was taken.

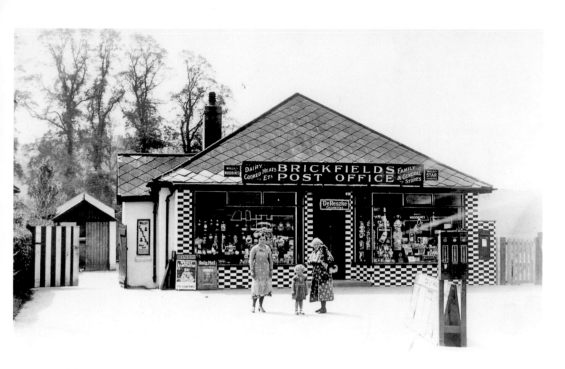

Brickfields Post Office

Brickfields Road originally linked Astwood Road with Tolladine Road and was a quiet rural lane. Initial development was restricted to Brickfields Terrace and a few houses close to the railway bridge. Glenthorn was a large house situated close to where Oak Avenue is now. The post office probably opened in the early 1930s when extensive council house building occurred in this area. The Cowley family were associated with this post office for many years. Having prominent advertisements for cigarettes is no longer an option for local shops.

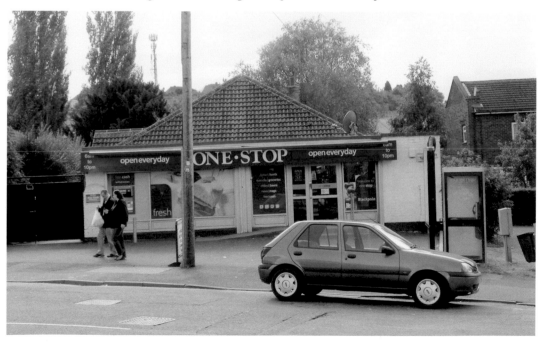

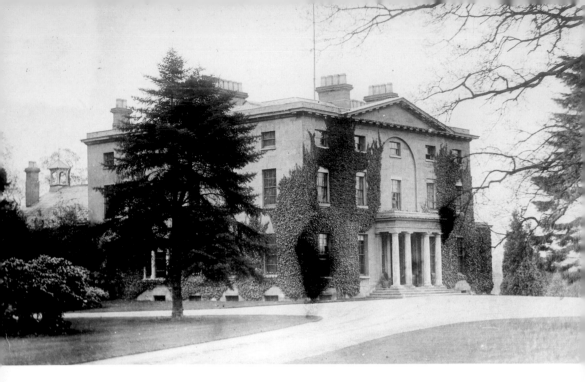

Perdiswell Hall

The hall is pictured on a postcard by Pitt & Son franked in 1910. The hall was built around 1787 but was demolished after a disastrous fire in 1956. The coach house survived, however, and was for some years the site of the local council nurseries. Offices have now arrived on the scene and, due to the diversion of a footpath, it is now difficult to admire the historic building. Local opposition to the diversion is keeping the issue alive.

Inset: Perdiswell Tennis Club in 1932. The coach house and hall were beyond the rear of the club house.

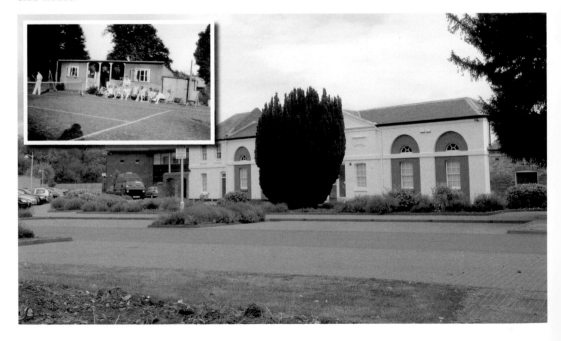

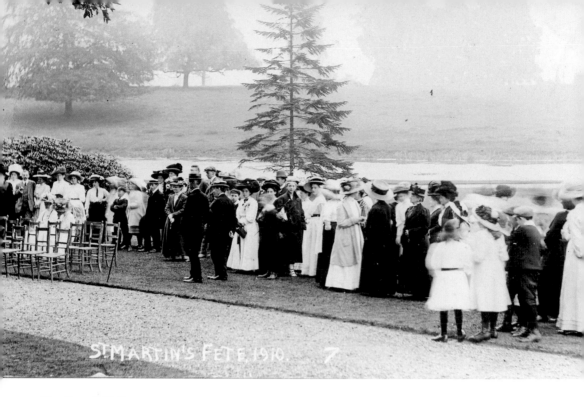

Perdiswell Hall

The vast grounds of Perdiswell Hall often played host to local fêtes. This postcard view by Max Fischer was franked in October 1910 and shows the large lake that has now disappeared. The lake was formed from small natural fishponds in the late eighteenth century and was ideal for ice skaters in the depths of winter. It was drained in the 1960s and then became ideal for filling with household refuse. A council-owned golf course now covers part of this location.

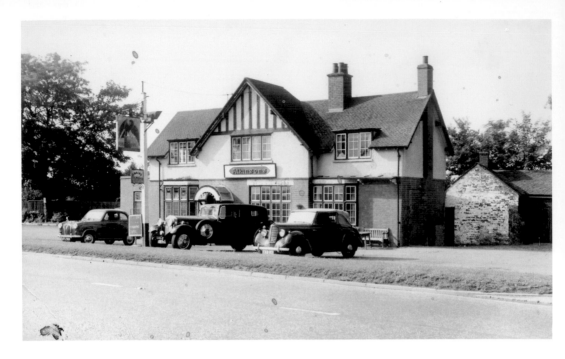

The Raven, Droitwich Road

Bentley's Directory for 1840 lists John Hutchinson as a victualler at the Raven, Red Hill. This is clearly a historic inn that was rebuilt at some stage in its life. The Raven was sold for around £3,000 in 1898 so this may have been when it was rebuilt. The photograph above was taken in 1960 just prior to the long stewardship of Neville and Mary Key (1962-1982). The Raven is now enlarged and majors as a restaurant pub.

Inset: The Raven around 1908 when Mrs Tredwell was the licensee.

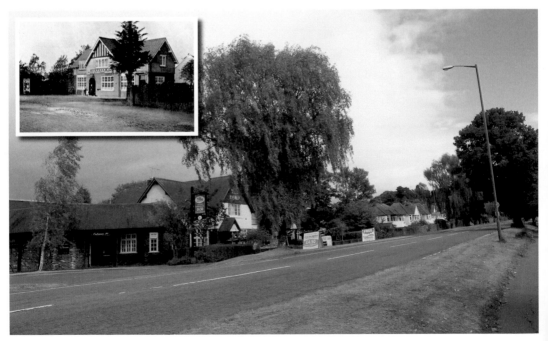

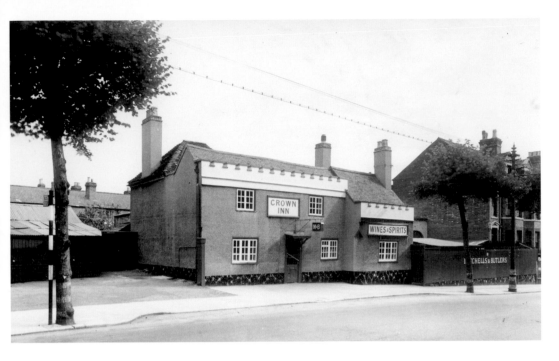

Crown Inn, Droitwich Road

The old photograph is dated 10 July 1950. The Crown was eventually replaced by the Deers Leap, and the brand new public house proved to be a very popular watering hole from the mid-1970s onwards. Times changed again, however, and in July 2009 the Deers Leap stood forlorn and forgotten (I am pleased to say it has just reopened – October 2009).

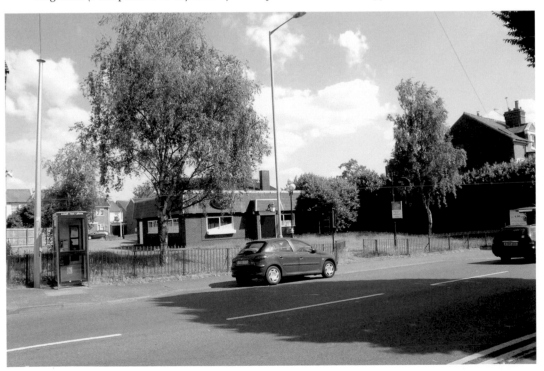

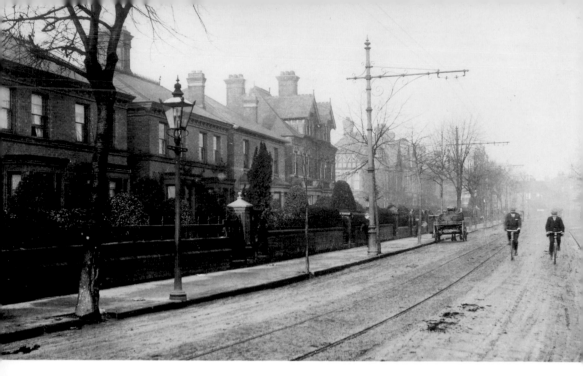

Ombersley Road

This view from 1908 was taken from south of St Stephen's Street looking northwards. Note the tram tracks in the middle of the road. The tram service terminated at the Vine. Back in 1908 the trams ran at ten-minute intervals throughout the day. The view is difficult to replicate today due to tree growth so I have opted for this view of Ombersley Road close to the junction with Northwick Road.

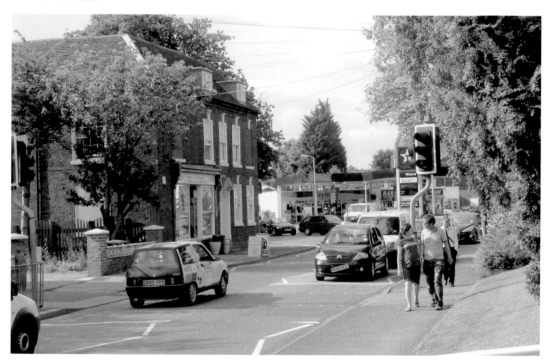

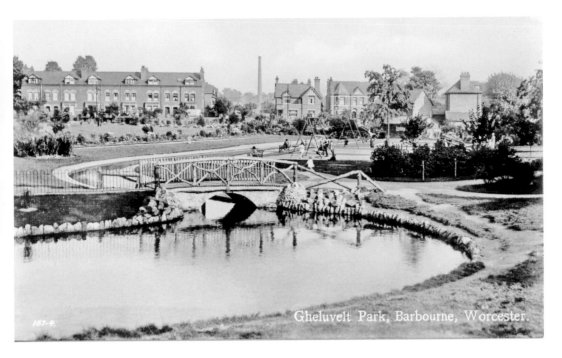

Gheluvelt Park, Barbourne, Worcester.

Gheluvelt Park

The old postcard was postally used in 1936. The park had a much more open aspect then and the houses bordering the Barbourne Road provided an interesting backdrop. I think the chimney in the distance belonged to a brick works by the canal at Gregory's Bank. The Barbourne Road is now a scene of regular traffic mayhem. The 'park and ride' buses that travel between the city centre and Perdiswell have sadly failed to help alleviate traffic congestion to any degree.

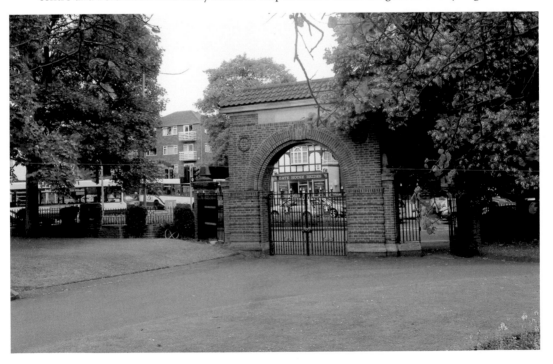

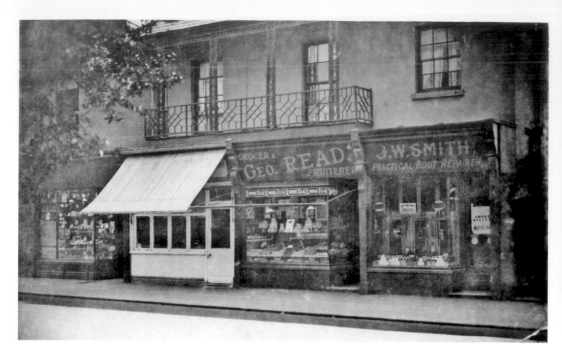

Barbourne Shops

The old view dates from around 1920. From left to right: J. R. Burbidge (watchmaker), Benjamin Potter (butcher), George Read (grocer and fruiterer), and Joseph William Smith (boot repairer). The ornate balcony has now gone and different sorts of businesses are *in situ*. The bus lane prevents the possibility of parking alongside these shops so deterring the passing motorist from providing them with much-needed income.

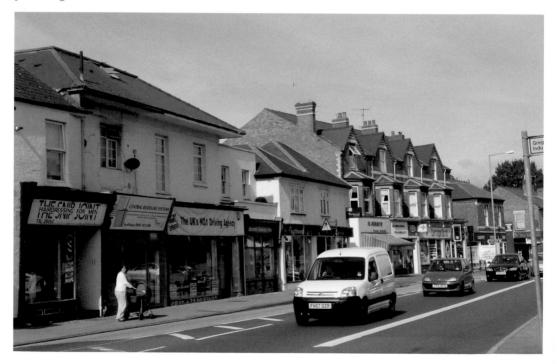

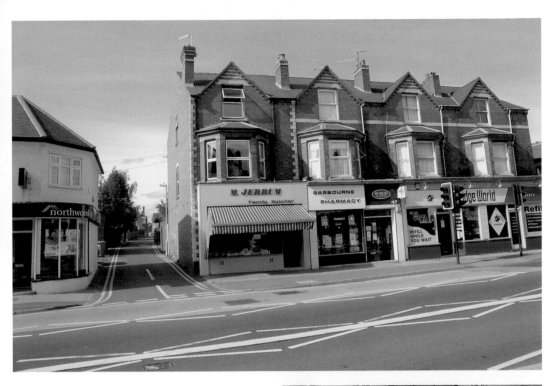

Barbourne Shops

Butchers situated in suburban shopping areas are now a rare breed. M. Jerrum, situated only a few yards away from where Benjamin Potter was in business, is bravely bucking that trend. Potter was still trading as a butcher in 1940 but had disappeared by 1955 when Preece Brothers, also butchers, were operating from the premises.

The densely populated roads and streets of the local community help provide the income for shops like these to survive.

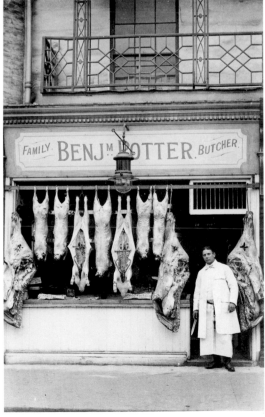

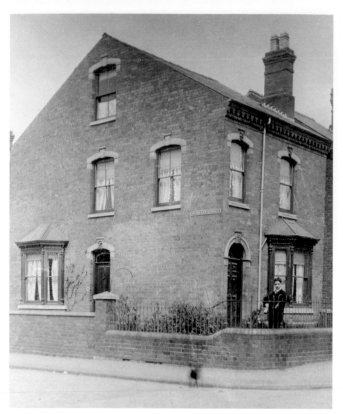

Berkeley Street

The old postcard featuring East Lynne was postally used in 1908. George Edward Hill, a GWR railway collector, was in residence at that time. This is the junction with Somers Road. Most of the housing in this area appears to be Victorian in origin and is well built. The River Severn and Pitchcroft are close at hand so this is a very pleasant area in which to reside. Varied shopping opportunities are available on the Barbourne Road and the city centre is only about a fifteen minutes walk away.

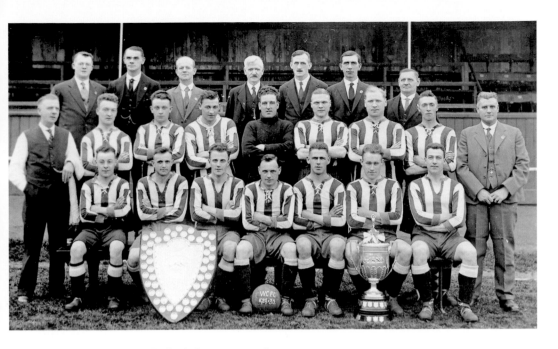

Worcester City Football Club, St George's Lane

The club was formed in 1902 and moved to the current ground in 1905. This is the team from 1929/30 photographed by E. & F. Baldwin. The players are, left to right: middle row: Garratt, Moss, Corbett, Boot, Birch, Slaley(?), and Isherwood; bottom row: Byers, Russell, Boswell, Smith, Kerr, Smith and Guest. Worcester City now face an uncertain future as plans for moves to a new location continue to be impossible to resolve in a satisfactory financial manner.

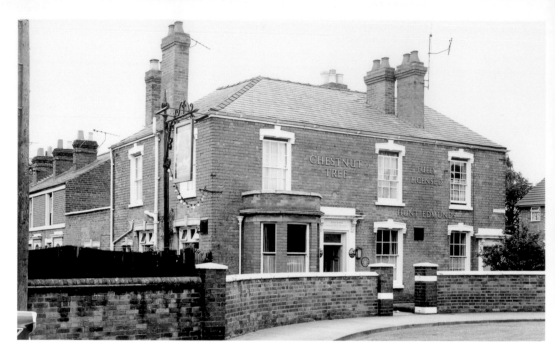

Chestnut Tree, Lansdowne

The old view dates from August 1967. Housed in an impressive building this public house continues to thrive amidst a densely populated locality. There is a listing for the Chestnut Tree in the 1879 *Littlebury's Directory* when F. Morris was the licensee. This is one area of Worcester where public houses are not in short measure; nearby are the Lansdowne Inn, the Coach and Horses, the Cap n' Gown, and the Talbot.

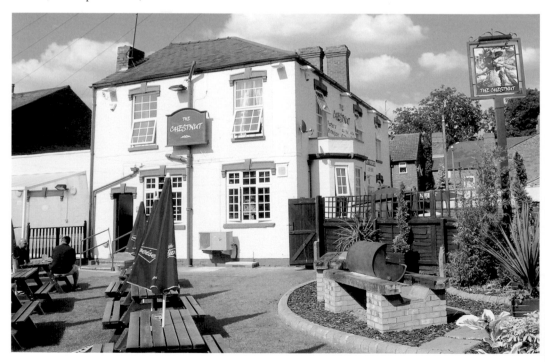

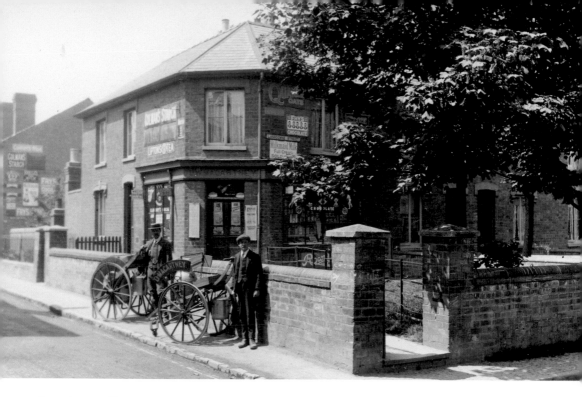

Lansdowne Shop

This shop was situated virtually opposite the Chestnut Tree and also had a nearby competitor in Mrs Kate Prosser at 13 Lansdowne Road (now Shakeys). Donald Walter Macartney was at this location in 1908 but had disappeared by 1936. This remained a corner shop for some years afterwards but is now a private dwelling.

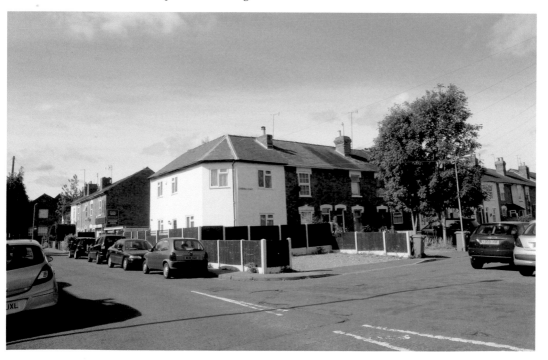

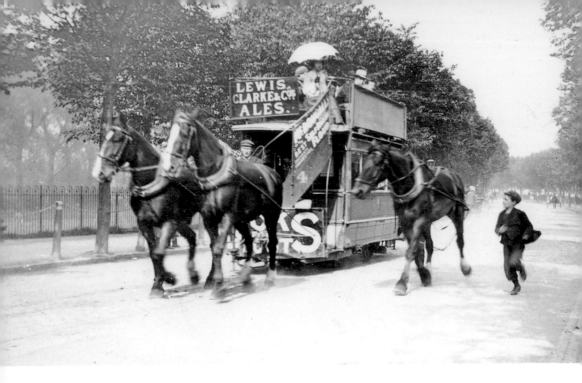

New Road Transport

Horse-drawn trams had appeared in Worcester in 1881. This is a two-horse vehicle that was introduced around 1894. The additional horse was needed in order to haul the tram up the incline at the Bull Ring. This task was performed by the young boy seen running alongside the horse. The Bull Ring was also the location of the tram depot (see page 84). Electrified trams replaced the horse-drawn trams in February 1904. Buses replaced the trams in 1928.

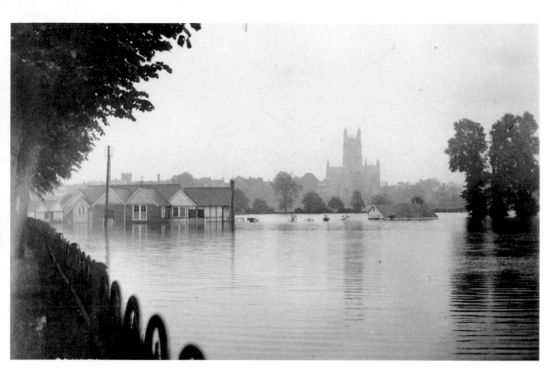

New Road Floods

Cricket at New Road was severely disrupted in June 1924 by a freakish flood that was fifteen feet nine inches above summer level. Unfortunately a similar flood in June 2007 (approximately fifteen feet seven inches above summer level) caused havoc and resulted in substantial financial loss.

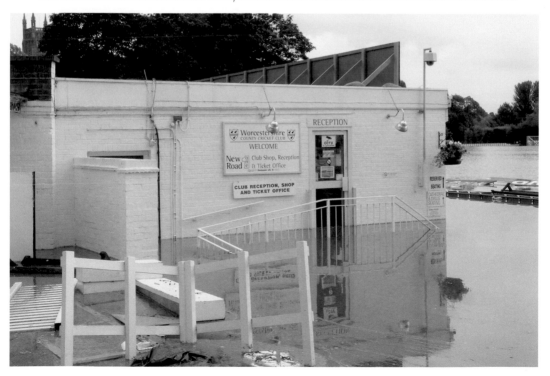

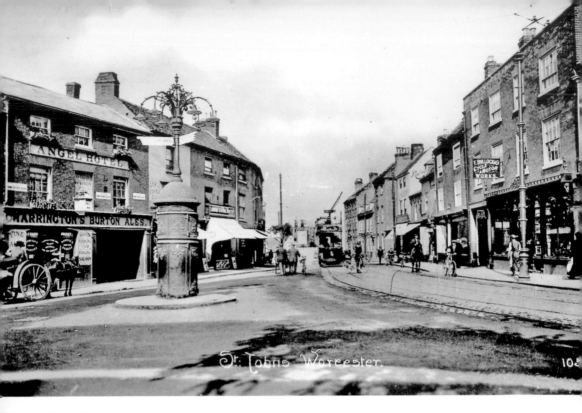

St John's Shops

The old view dates from around 1916. Shops on the right include Robert Birch (grocer) and F. Bullock & Company (cycle & motor works). The electric tram is roughly level with the entrance to the tram depot that was on the left (now the Co-op supermarket). Some older properties have been replaced but the modern view is quite similar apart from the background Bull Ring flats. The former Angel Hotel is now Angel Fruits. The large sign adorning the building remains intact.

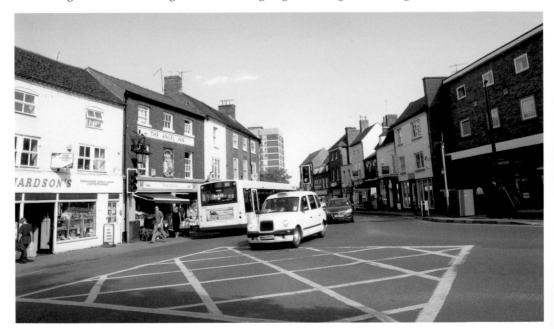

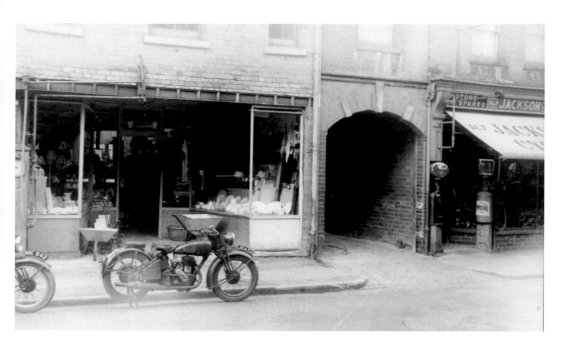

St John's Shops

The old view is from 1947 and features the cycle shop of Alf Jackson. The shop had previously been owned by Percy Lewis who had started the business in 1918. There was a large workshop behind the shop. In the early 1920s Percy installed what is believed to have been the first pavement petrol pump in Worcester. The other shop has no identifying signage but is probably that of L. G. Dobson (glass and china dealer, ironmonger and paint merchant). The shops today are completely different in character. The new buildings beyond have been built in a suitably matching style.

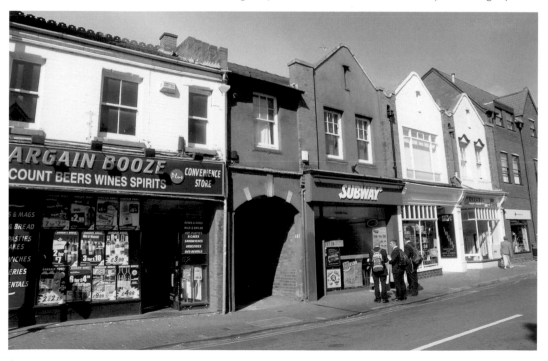

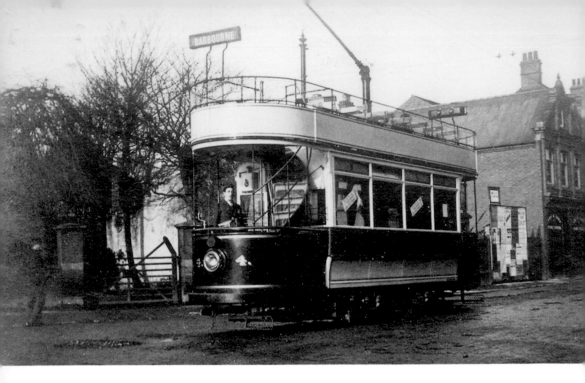

St John's Transport

The old postcard was franked in 1906 and features tram No. 4. The gate to the left of the tram led to Ivy House which was the location of the St John's Ladies College run by the Misses Sessions and Wylde. The building to the right of the tram (then a Co-op) is now the location of the excellent Indian restaurant, Pasha. The next building looks in fine fettle and Barber Town has recently started to trade from here. The stone archway on this building has the inscription: 'Cousens Hygienic Machine Bakery, A.D. 1891'.

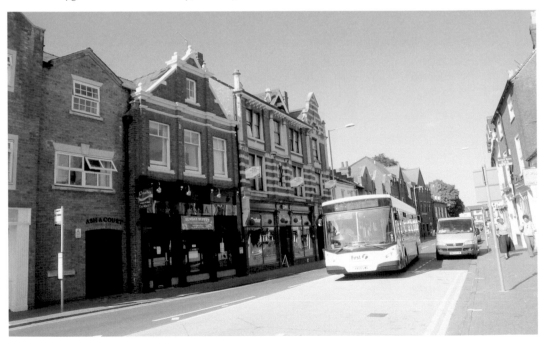

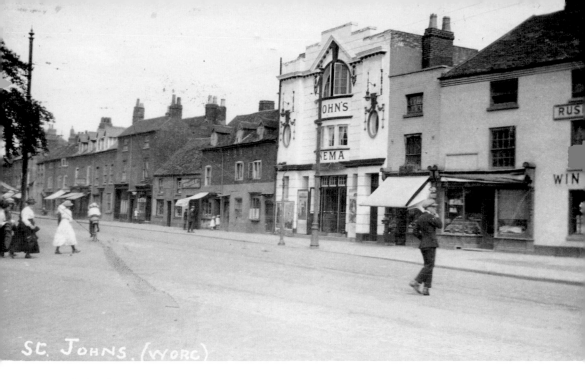

St John's Cinema

The old postcard was franked in 1919. To the right of the cinema are the premises of Mrs Mary Frances Light (grocer). Further to the right is the Swan Inn. The cinema was built in 1914 on a site partially occupied by the King's Head Inn. The proprietors were the Godsall (possibly Godsell) brothers and the cinema hosted Worcester's first talking movie in 1929. The cinema closed around 1959. In recent years the cinema was altered into a nightclub. The building and its neighbours are now owned by Sainsbury's and a new future beckons.

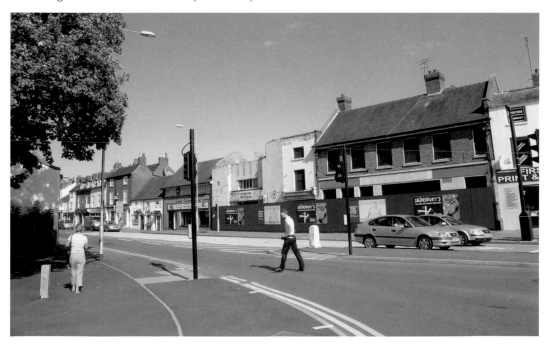

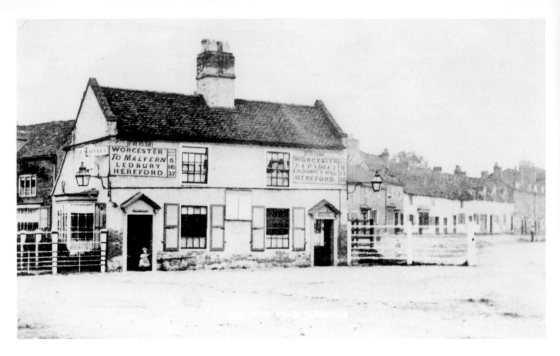

Malvern Road Turnpike

The old Edwardian postcard features a Victorian image of the tollhouse which closed around 1870. The coming of the railways reduced the power of the tollhouse owners and the fees they charged were a constant target of public discontent. Inevitably they fell by the wayside! The defunct tollhouse remained a part of the St John's environment until demolition around 1936. This is a very different scene today and the location has become a place of traffic congestion with the opening of the new Sainsbury's supermarket and a new sports centre. Will a new form of tolls make its appearance in Worcester?

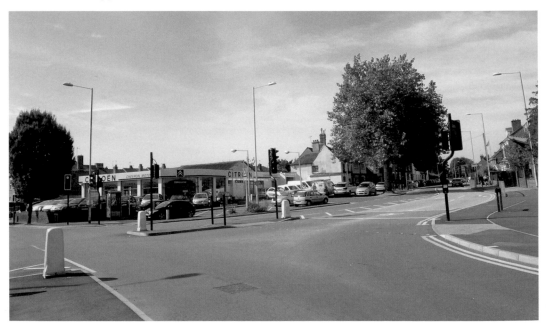

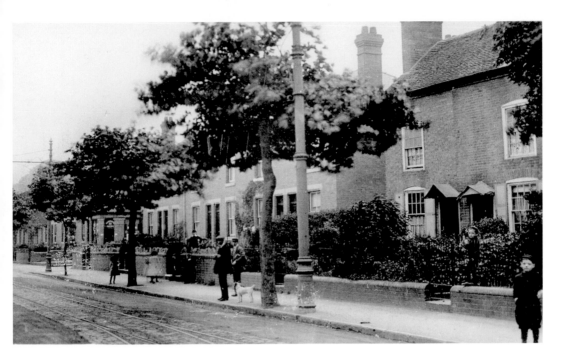

Malvern Road beyond the Turnpike

The houses on the right of this postcard, that dates from around 1909, have since disappeared. The terrace of Edwardian houses ends at the junction with the then newly-built Abbey Road. In late Victorian times there had been a blacksmiths in this location. The shop on the corner of Abbey Road and Malvern Road (a traditional corner shop in Edwardian times) is now a fishing tackle shop.

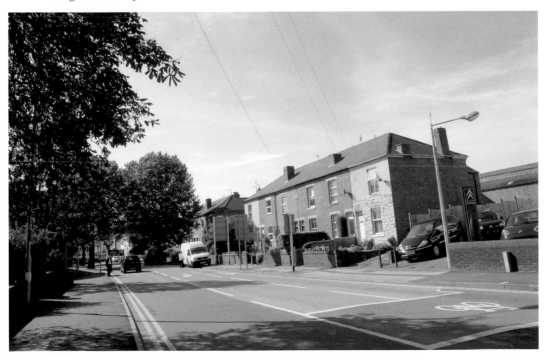

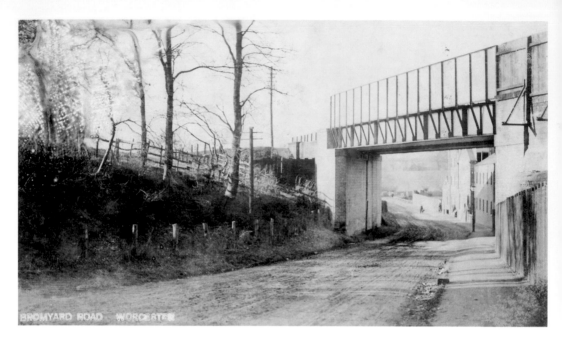

Railway Bridge, Bromyard Road

This was very much a rural location in the early 1900s. Just beyond the bridge is the Ice and Cold Storage Works that commenced operations under the stewardship of Frank Heffer in the mid-1890s. In Victorian times it was the steam-driven flour mill of William Hadley & Son; built in 1867 it replaced a smaller mill that had utilised the waters of the Laugherne Brook. The modern view, looking in the opposite direction, shows that this building still remains in industrial use.

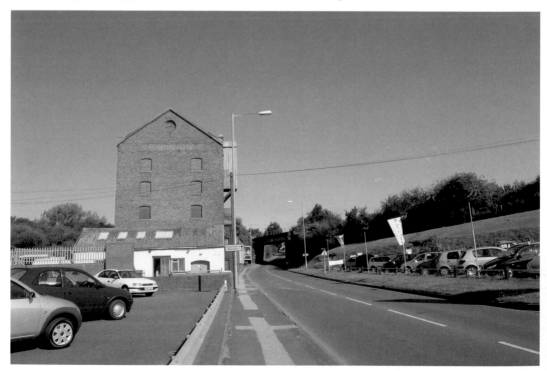

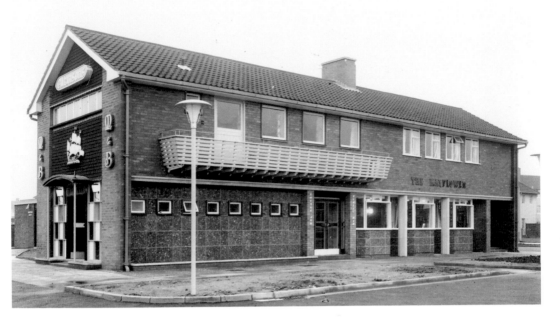

Mayflower, Dines Green

The roads and public houses on this estate have a distinctly Tudor and usually nautical connotation. The old view of the Mayflower dates from 1959. Unfortunately the Mayflower sign has now disappeared from above the entrance doors. The other public house on the estate, the Drakes Drum, is currently boarded up and awaiting a new landlord or a new future.

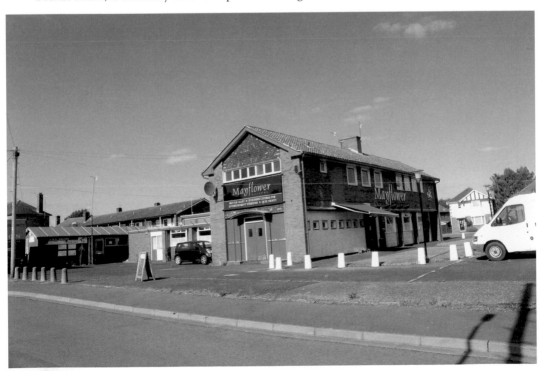

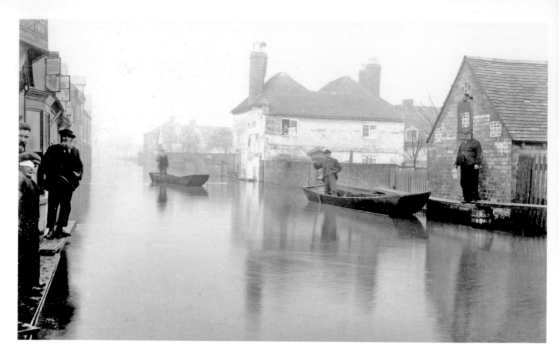

Hylton Road in Flood

On the extreme left of the old view (probably the flood of December 1900) is the Chequers Inn. The licensee was Joseph Yeates who was also a fruiterer (see page 81 of my book, *Pioneers of Photography in the City of Worcester & Around*). The view is looking northwards from near the junction with Chequers Lane. The modern view of workers from ETB (Exhaust, Tyres and Batteries) was taken during the November floods of 2000.

Inset: Floods can be fun for the young. A photograph taken close to the *Worcester News* premises during the flood of June 2007.

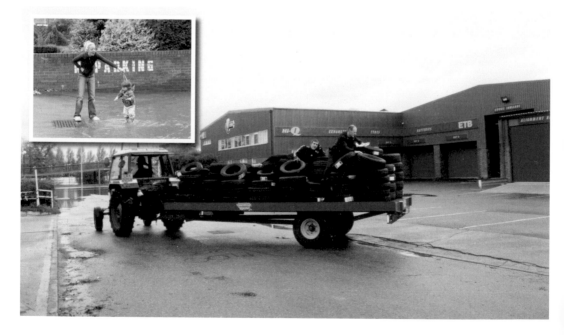

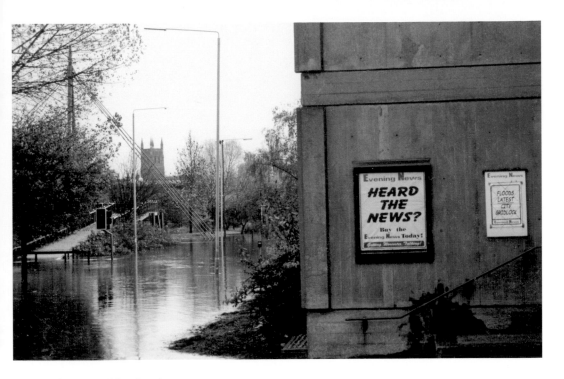

Hylton Road in Flood

The advertising hoardings on the *Worcester News* premises in November 2000 did not have many viewers and as the city was, indeed, gridlocked this was a very quiet spot. A similar scene in June 2007 put the speed camera out of work. Scenes such as these should not recur now that a flood alleviation scheme has been put in place.

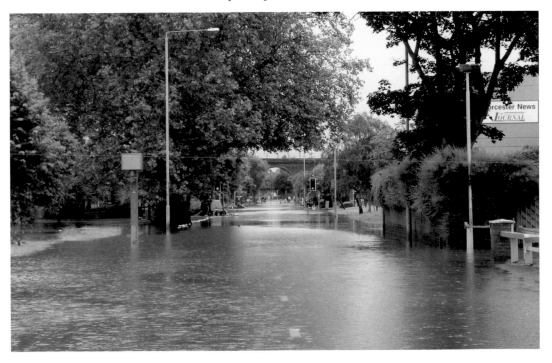

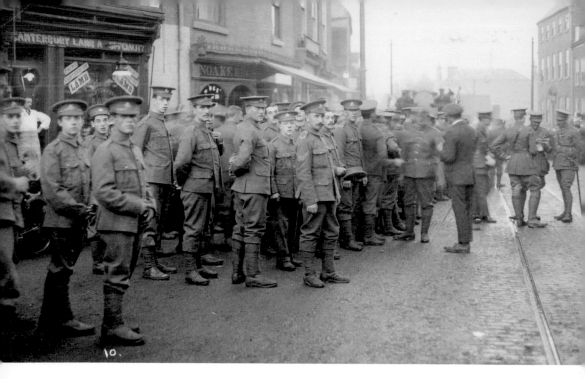

Changing Attitudes Through Time

The old postcard from October 1914 shows military recruitment in St John's. On the back is written: 'Just a line to say that Tom has enlisted in the RAMC and goes to Aldershot on Monday'. I wonder if Tom returned intact from the War? Nowadays our attitudes to war are changing. The photograph taken in Angel Place during September 2009 shows that many people were willing to sign a petition against the war in Afghanistan.

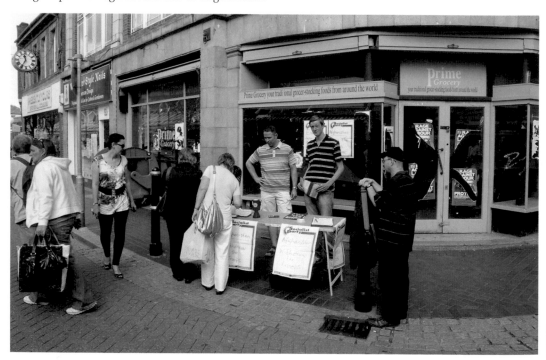

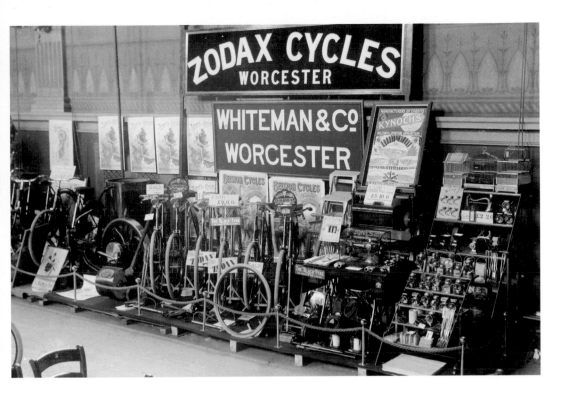

Changing Displays Through Time

The old photograph features an exhibition display by Whiteman and Company of Silver Street (see page 54) around 1910. They sold Ariel, Beeston and Zodax cycles. Other items on display include a sewing machine, lawn mowers, birdcages, mincers and various other items of ironmongery. The modern view features a fine display of motorbikes outside the premises of Skellerns in Sidbury. In the left background can be seen part of the Waterside apartment development at the porcelain works site.

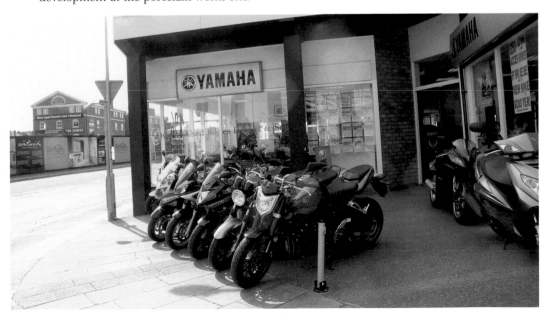

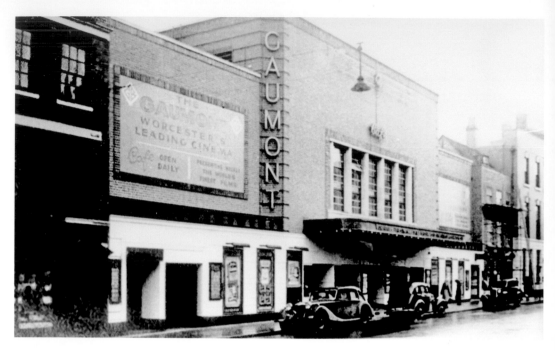

Changing Cinemas Through Time

The Gaumont is featured on an undated postcard. The cinema opened in October 1935 but became a bingo hall some years ago. The Gaumont is probably best remembered for hosting concerts by pop icons such as Jimi Hendrix, The Beatles, The Rolling Stones, Mott the Hoople and David Bowie. The Northwick, built in 1938, is featured on a photograph from the early 1990s when it was in urgent need of a new use. Historically the Northwick is a very important cinema as it contains the work of John Alexander, the renowned Art Deco designer. This is now Grays furniture store and is well worth a visit.

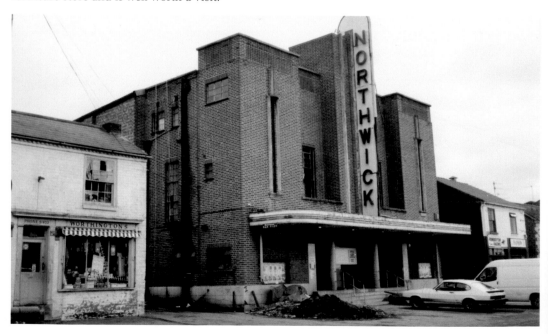